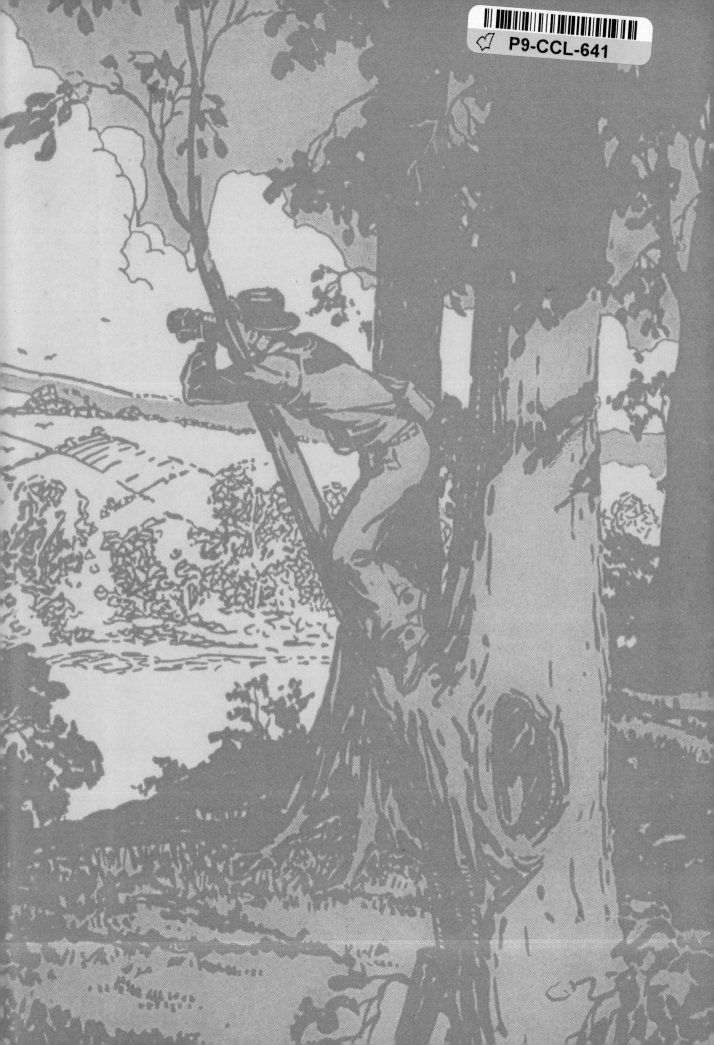

Hello Nature

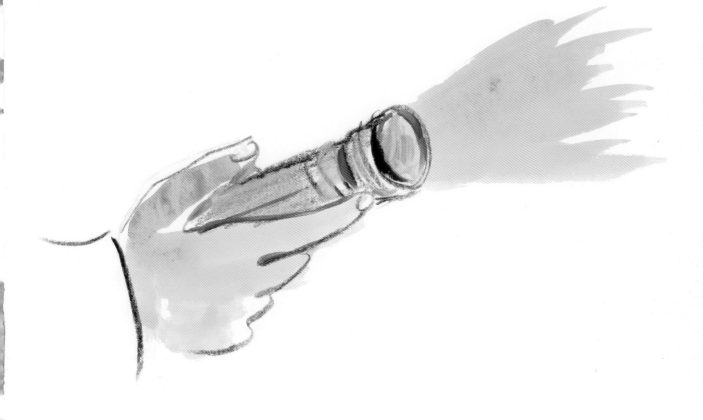

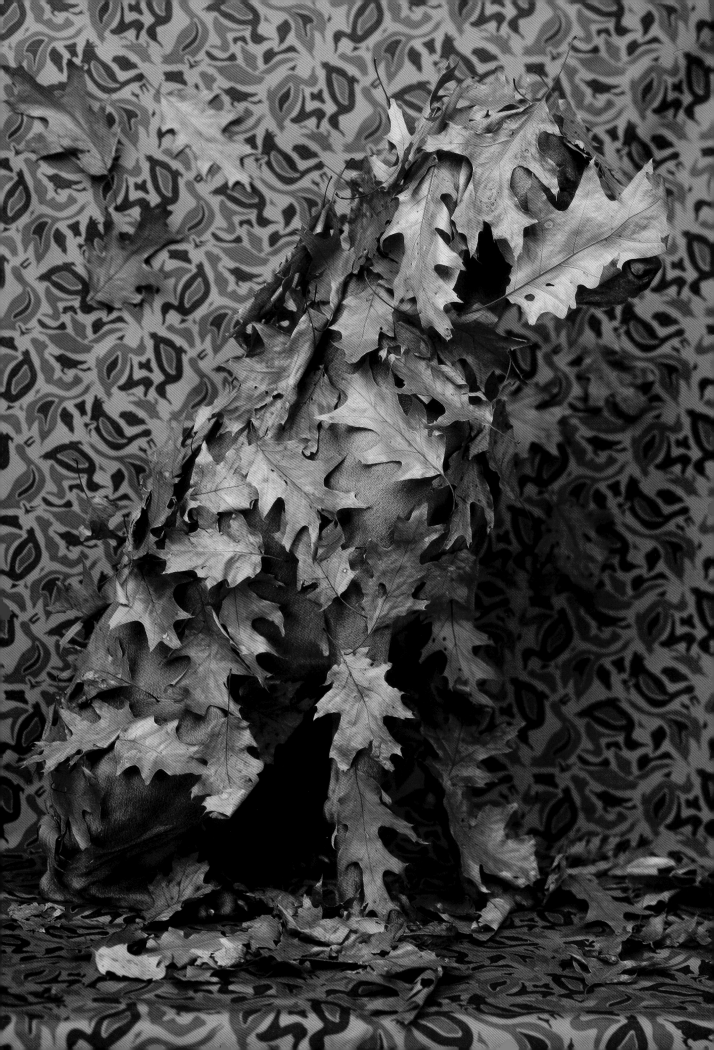

William Wegman

Hello Nature

How to Draw, Paint, Cook, & Find Your Way

BOWDOIN COLLEGE MUSEUM OF ART, BRUNSWICK, MAINE

DELMONICO BOOKS · PRESTEL | MUNICH LONDON NEW YORK

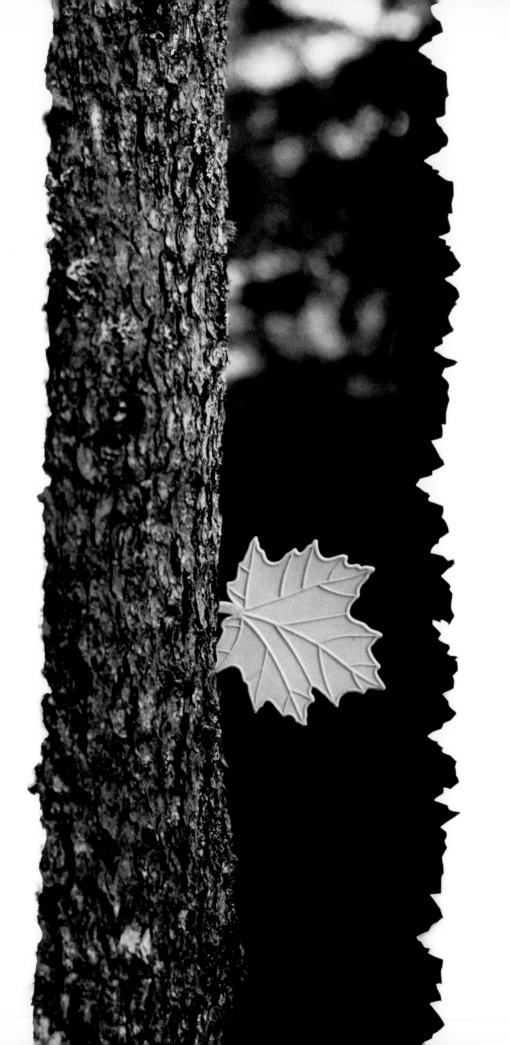

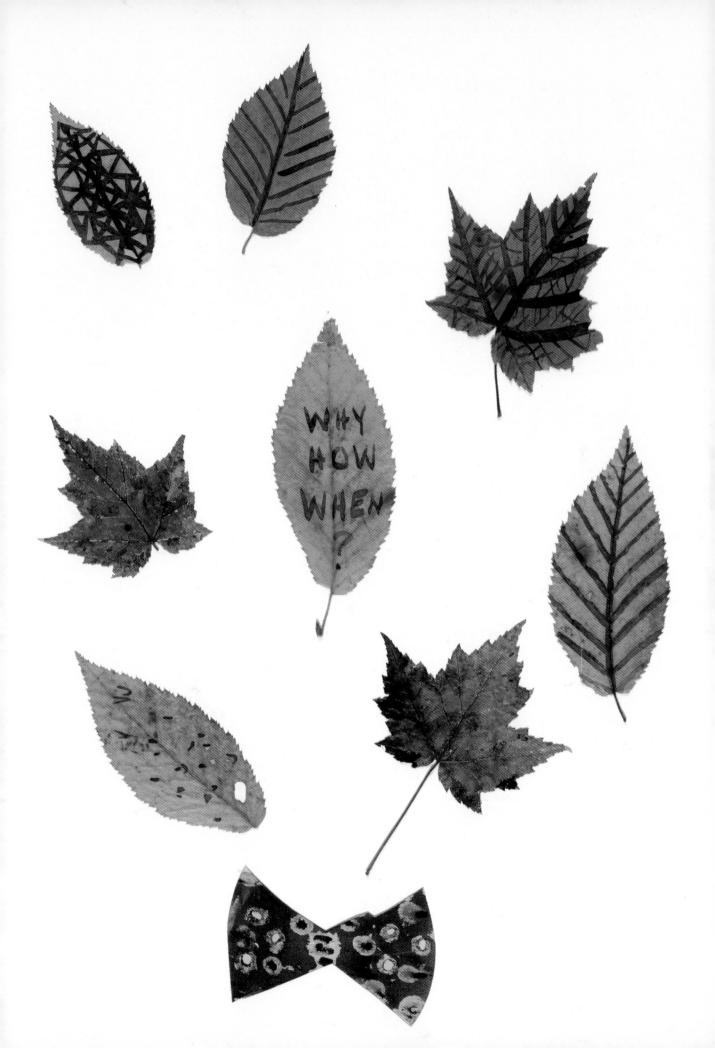

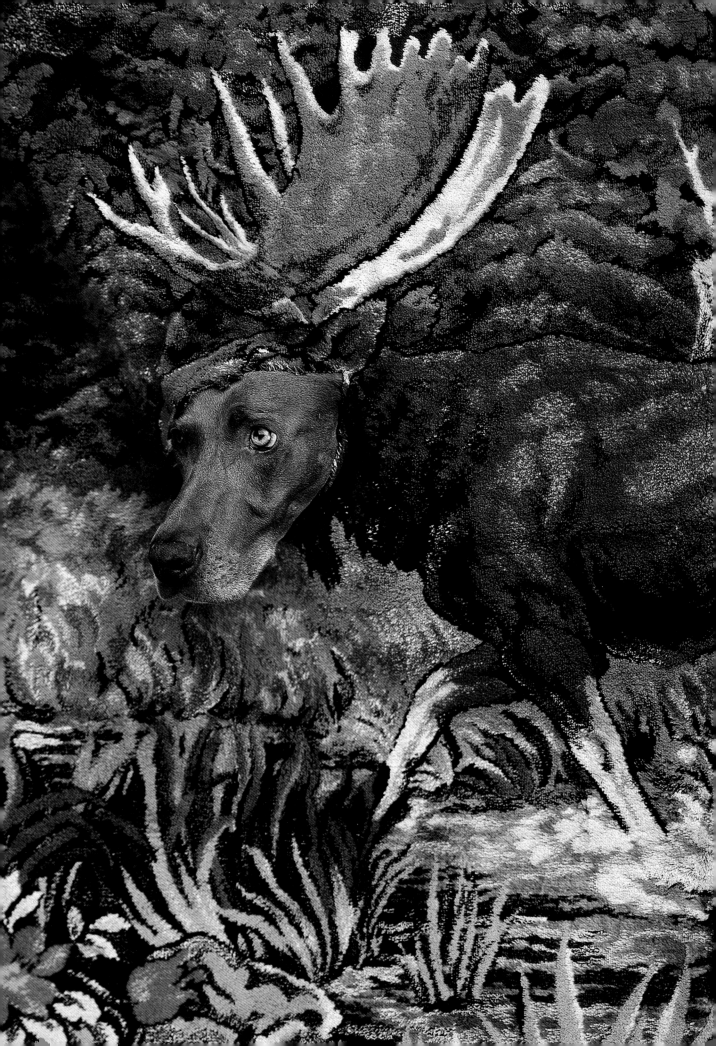

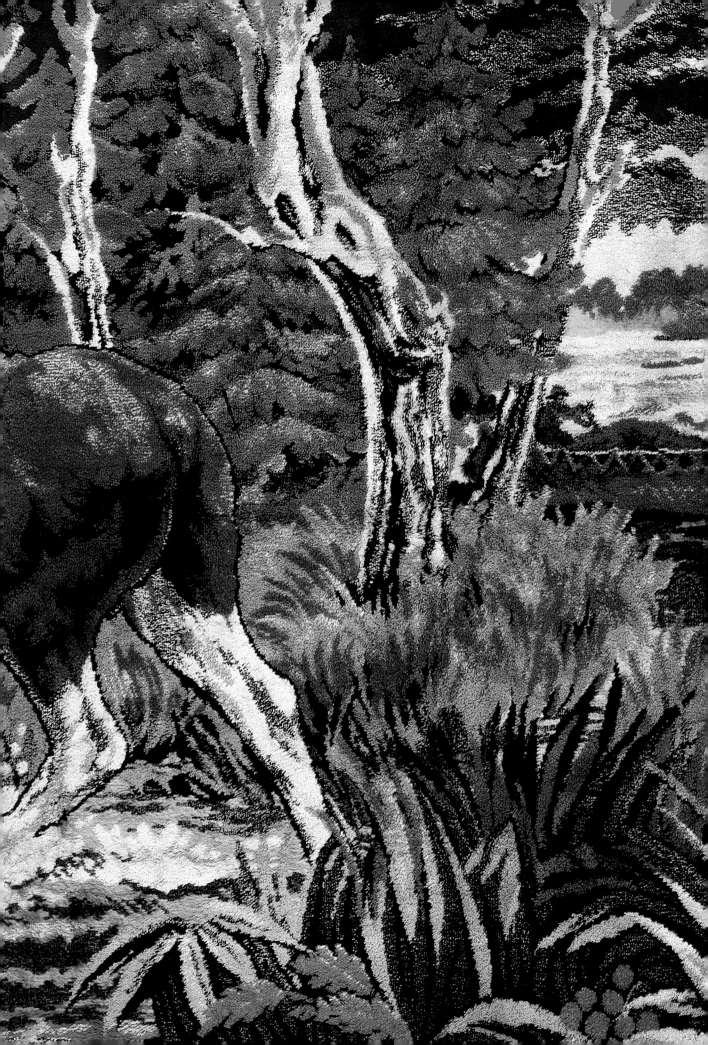

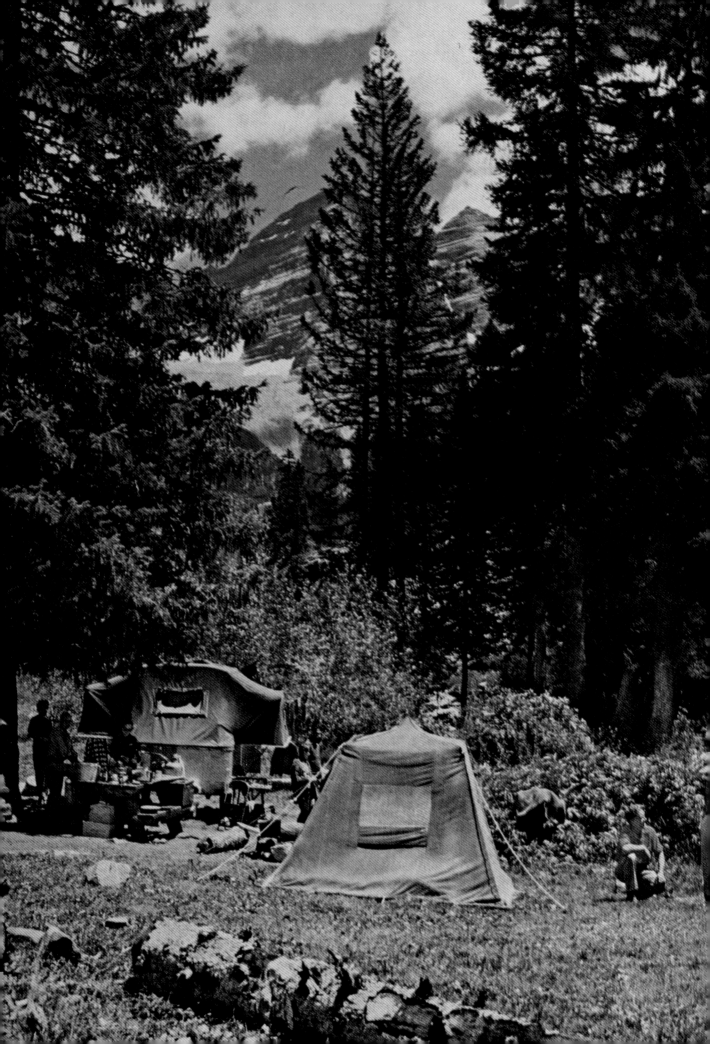

Contents

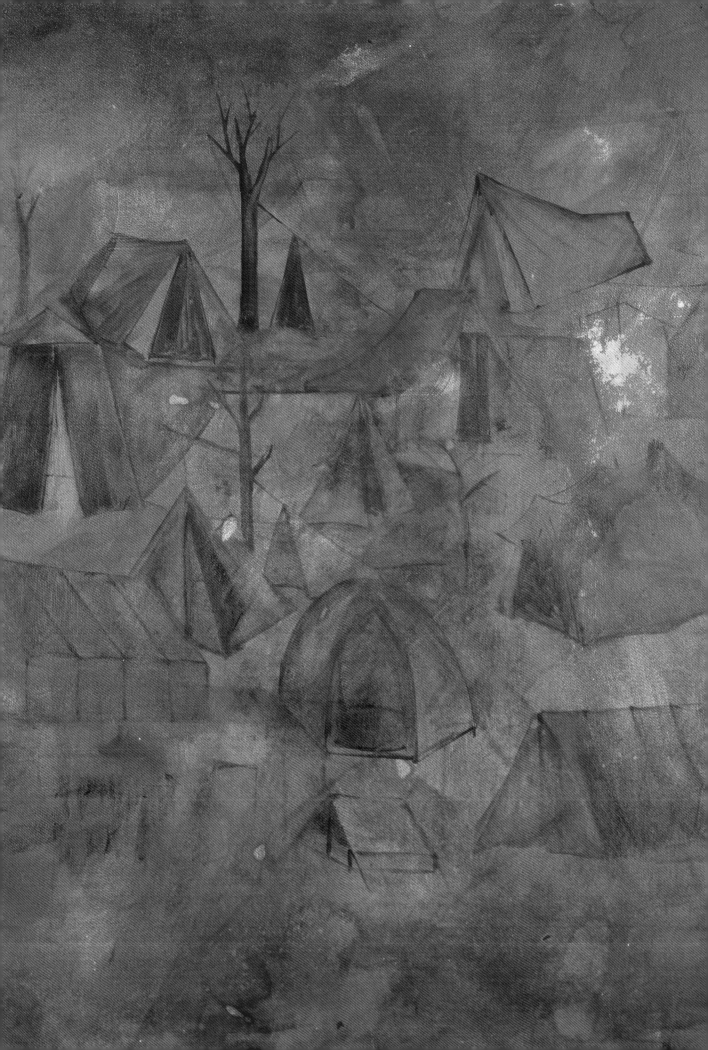

William Wegman

William Wegman is perhaps most widely known for his books on hunting and fishing but he is also versed in hiking and camping and Nature herself.

When others say they know a lot about these matters Wegman actually does something about them.

When not working on his books and thinking about them he likes to be out in nature hunting, fishing, hiking, camping and experiencing life.

About the Author

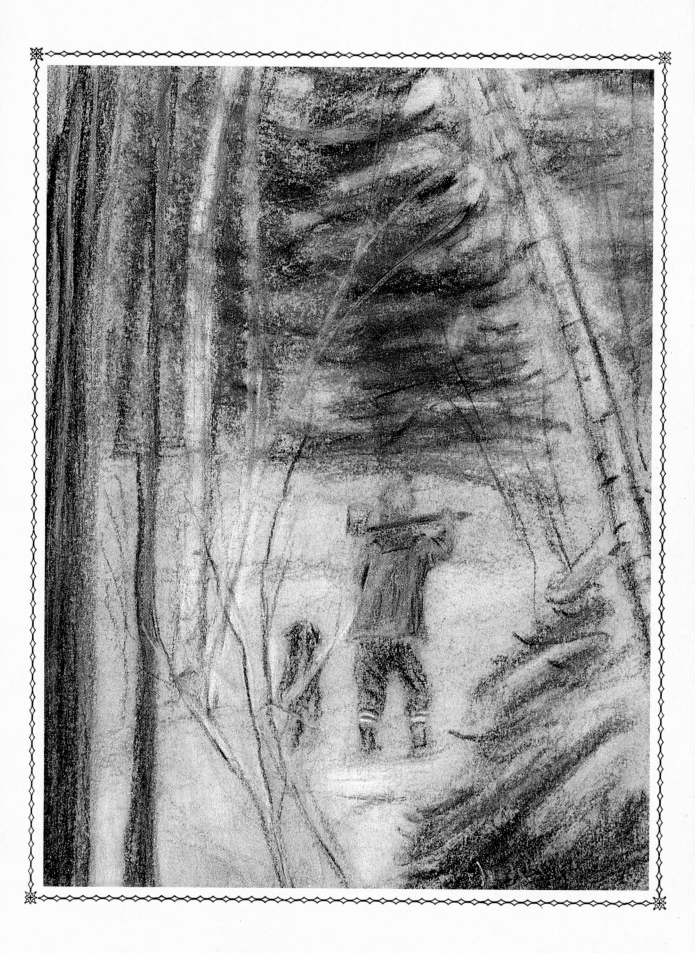

ABOUT THE AUTHOR

by WILLIAM WEGMAN

GROWING UP in rural Massachusetts before anyone I knew had a television set, I spent most of my time in the woods. Home of the rabbit, the squirrel, and the deer, the pheasant, the woodchuck, and the chickadee to name a few. In the swampy woods of Longmeadow there was quicksand to fantasize about. In a test of the terrain I actually got stuck and had to be rescued by my buddy Junior Manzi. In school I was known for my shyness and my artwork. The earliest painting I remember making was of a duck and a rock with a question mark. When I was seven we moved to the smaller, even more woodsy quarry town of East Longmeadow. We were surrounded by red sandstone quarries. The quarries were our playgrounds. Some had filled with water of mythical depths. There was a car 100 feet down at the bottom of the one across the street. Some were still in use. Cliffs and cables threaded through the woods. If a cable snapped, it could decapitate you. We all had BB guns, but I preferred bows and arrows. Sometimes I made paintings of Indian lore from pictures in the *Book of Knowledge* using pigment I extracted from berries. I was part Indian. Anti-cowboy. I loved feathers and had a collection of arrowheads. I got hooked on the *Hardy Boys*, reading them by

East Otis Reservoir, Massachusetts, 1950

flashlight long after I was supposed to be asleep. I had a book on watercolor painting technique by Arthur L. Guptill. I had a paper route and a dog. My mother was an amateur watercolorist as was my uncle Evert, the eldest of six Wegman brothers. Evert had taken some adult classes and showed me the wet-on-wet technique used in making stormy skies, and it was Evert who supplied me with paint, good paper, and sable brushes. I got pretty good at it. I painted the field out our picture window and the quarry in the woods in our backyard. On calendars, I appreciated the paintings of hunting dogs on point in fields. I made a nice little pastel of me and my dog, Wags, walking into the woods. I assembled a Super radio by taking apart other radios and hooking them all together. I could get reception only by sticking the one loose wire into a jar of water. I hitchhiked. In the fifties there was not so much parental supervision. As long as we were home for dinner.

PFLUEGER, MITCHELL, SHAKESPEARE

Our family vacation spot was the campground of the Otis reservoir in central Mass., about 30 miles from our home. We had a tent and slept in sleeping bags on fold-up cots. There was a picnic table and fireplace. We kept food in the cooler. We had a Coleman lantern. We rented a motorboat. It was on the Otis Reservoir that I caught my first fish, a yellow perch. I became an avid fisherman. The spinning reel was a new thing. Mine was probably a Pflueger and later a Mitchell 300. The rod? Could have been a Shakespeare… In the summer months I rarely slept inside. I had friends for different categories of interests.

East Longmeadow, Massachusetts, June 1957

Hockey/baseball: Butch. Huts and cars: Ray. Fishing: Donald. I was a Boy Scout but disliked it (almost as much as summer camp). There were rules and meetings. The badges were cool but annoying to achieve. Besides, I already knew everything you needed to know about knives and hatchets and knots and fires.

Kennebago Lake, Maine, 1958 (Photo by William Dornbusch)

My fishing buddy Donald was fanatical. We fished from April 1 to September 15 (the last day of fishing season) for bass, bluegill, perch, pike, and trout in the streams and ponds of Massachusetts and Connecticut, anyplace we could reach by bicycle. Mostly we fished for brookies in the Scantic, a stream that flowed from someone's backyard down into northern Connecticut. We were always looking for new water, some untried spot. From outdoorsy magazines like *Argosy*, *Field and Stream*, and *Outdoor Life* we read about Rangeley, Maine, home of the landlocked salmon: "The leaping gamester that challenges the resourcefulness of the most ardent angler." A painting depicts the curling fish, mouth agape, about to take the fly. Is that a Parmachene Belle it is about to engulf?

KENNEBAGO LAKE CLUB

Rangeley is 350 miles north of East Longmeadow. Too far to bike. One of us needed to turn sixteen. That would be Donald. In July 1957, four of us (ages fourteen, fourteen, fifteen, and sixteen),

piled into the fifteen-year-old's family DeSoto, and nine hours later we were in Rangeley.

The road to Kennebago Lake, to us the most alluring of the Rangeley Lakes, was 12 miles of bumpy dirt, a logging road. We weren't good drivers. Eventually one of us hit a rock and water or gas spewed out of the DeSoto. We remained on this rock for some time. Luckily a guy in a pickup truck came by. "We're from Massachachussetts, East Longmeadow, near Springfield," I explained. "Hop in the back," he said. We were driven to Kennebago Lake Club, and that's where we met Bud. Bud Russell. Bud owned the Club and he took care of everything. He had our car fixed and put us up for a week. The Club consisted of a main lodge and a series of cabins, about fifteen in a row to the right and four or five bigger ones on the left of the main building. We stayed in a real log cabin with bunk beds and a stone fireplace. There was breakfast in the main lodge at 6 am, buffet dinner (including lobster) at 6 pm. Bud set us up with fly rods and a Rangeley boat and showed us where to fish. "Know how to cast with a fly rod?" "Of course we do!" Not.

Fly fishing was different from what we were used to. Unlike spin fishing, where you *cast* a lure, in fly fishing you *throw* the line. Like a rope. Kennebago, like most of the lakes and streams in the Rangeley region, is fly fishing only. Almost everyone there who fishes, fly fishes. Not just the waspy types. Trolling lures, if not illegal, are certainly frowned upon. Our Davis spinners, Daredevils, and Mepps would have to be smuggled in like fireworks from New Hampshire.

NORMAL, BRECK, STELLA

In high school I thought it would be a good idea to get my grade point average up, so I took art. Sports had replaced fishing as my dominant interest. I was on the hockey team. I painted pictures of my skates. The Breck Girl became my significant muse. If only I could paint that well.... I made some nice sketches in charcoal

of rooftops amidst leafless trees. I was good at drawing Sabre Jets in perspective. So good was I that my art teacher, Mrs. Laramee, said I should go to art school. At her suggestion, I applied to Massachusetts College of Art (formerly know as Mass Normal. That's weird . . .).

Boston is a great museum and music city. Mass Art was right around the corner from the MFA and the Gardner Museum. Forget the Red Sox and the Bruins, I became a monk for art and music, spending much of my time in museums, churches, and concert halls. An exhibition at the Rose Art Museum at Brandeis of Frank Stella's black-on-black paintings had a huge impact on my recently opened mind, as did one of

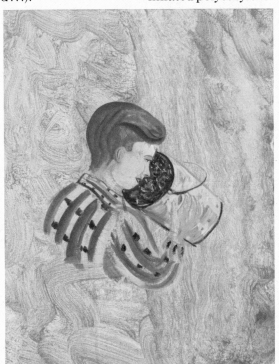

What is Sound, 1985, oil on canvas, 14 x 10⅞ inches

my teachers, the mysterious and abstruse Arthur Honer, who had taken LSD with Leary and Huxley and Dan Kelleher and who persuaded me, with a shrill laugh, not to major in teacher education in my junior year but in painting. Looking forward and backward, I invented a style that became popular at Mass Art (as I recall). Hard edge splatter. Pollock/Stella. I used a lot of masking tape.

In graduate school at the University of Illinois at Urbana-Champaign, in 1965–67, I moved even further from the woodsy watercolors and the Breck Girl of yore into the area of shaped canvases and modular painted sculpture, works that artists of the period generally referred to as "floor pieces." Alas, by my second and final MFA year, I had moved away from painting altogether. Under the spell of the new (as presented in art mags) I became a per-

formance/installation artist. Stunningly, given my lack of aptitude for science and engineering, I was given a fellowship with the U of I department of electrical engineering. There I worked on my thesis project: an interactive environment inside inflated polyethylene rooms booby-trapped with triggers and sensors that activated a variety of sound and light machines.

FUNNY STRANGE

Funny strange how in 1985, twenty years of photo and video and a dog named Man Ray later, I should find myself dreaming about the Breck Girl. I yearned to paint. But in order to do so I had to ignore everything I had learned in art school. Smithson, Morris, Nauman. All of Op Art, Pop Art, Earth Art, Body Art, Minimalism, Conceptual Art. Video, photo, and performance. I had to go back to high school and before . . . to watercolors with my mother.

In 1978 I bought a little log cabin in Rangeley. There, in the Maine woods, with New York City out of mind, I began. My first attempts were startling. Really bad. I had assumed I would know how to paint. BFA, MFA notwithstanding, I did not. Oil on canvas would require new thinking and some skill development. A revised manifesto was implemented and strictly adhered to. The basic tenets were outlined in a painting titled *Hope*. It was a picture of my cabin alongside a portrait of the Breck Girl. The painting included a painted text announcing my new direction. And my opinion of it. No need for critics to intervene. I was happy and I painted lots of pictures as if I had never been to art

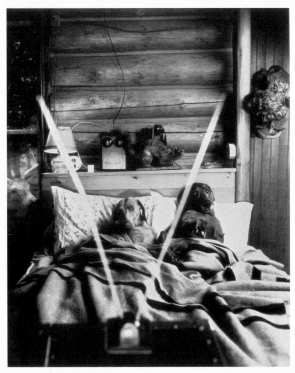

Ray and Mrs. Lubner in Bed, 1981, 20 x 24 Polaroid

various textured fields. The last paintings were amorphous swaths of color minimally inflected with recognizable subject matter (usually boats and airplanes). Not knowing how to proceed further in this direction, I put painting aside.

LOTS OF DOGS

That was ok. I had dogs. Lots of dogs. In June 1989, my dog Fay had given birth to eight puppies. In July, we moved Fay and her litter into York's Lodge, the rambling wooden structure across the road from my log cabin (a former hotel, York's was once known for their "Rustic Modernization in the Heart of the Woods" but had been boarded up for years), which I had recently acquired and was fixing up to live and work in. Raising the puppies and photographing them took much of my time. It was a spirited, eventful period. One thing led to another. By the early 1990s Fay and her children — Chundo, Batty, and Crooky — had become the major subjects of my photos, books, films, and videos.

The town, the school, the woods, and lakes of Rangeley provided a hospitable and inspiring environment for these projects. I arranged to import the 20 x 24 Polaroid camera and crew, reprising the 1981 adventure with my dog Man Ray.

Two major endeavors stand out in my mind. *Little Red Riding Hood*, a children's book featuring Fay as mother and grandmother, Chundo as the wolf and the woodsman, and starring Batty as Little Red, was shot on location in Rangeley with the 20 x 24 Polaroid. This was followed by a

school, finding subject matter in books similar to the childrens' encyclopedias I had immersed myself in as a child. Another little painting took its form from a crude illustration in a childrens' science book called *What Is Sound*. Over the next few years the paintings evolved, expanding in size and technique. Pictorial incidents on

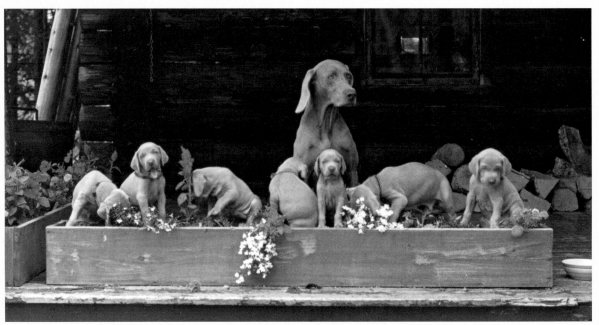

Fay and her puppies, Rangeley, Maine, 1989

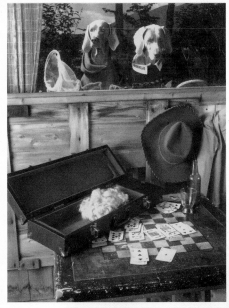

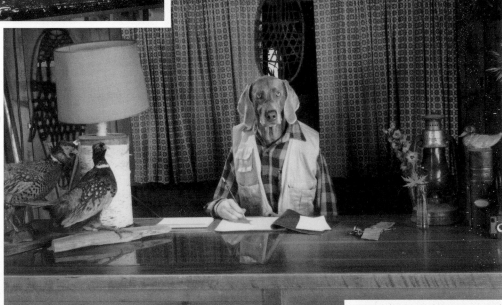

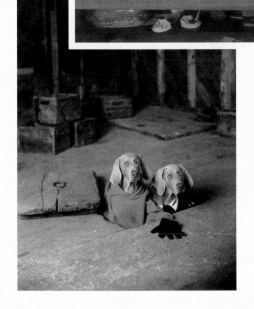

Batty as Little Red Riding Hood,
1993, 20 x 24 Polaroid

A FIELD GUIDE

In 1993 I was invited by Lapis Press to make a limited-edition artist's book. Sure, I would love to make a book. After some thought I decided to attempt a project that had been ruminating, in retrospect, forever. A fieldish nature guide. Something that would combine the New England transcendentalism of my inherited birthright with a lifelong interest in hiking, fishing, canoeing, and birch bark. Have you ever made tea from birch bark? I was surrounded in my Maine studio by an ever-growing collection of guide, camping, cooking, scouting, and nature craft books, and the project took off. Photographs, altered photographs, collages, paintings, how to use a compass, texts about the environment, specimens, recipes, camping, and so forth. In all, twenty unique, very handmade, buffalo plaid wrapped copies of *Field Guide to North America and to Other Regions* were assembled.

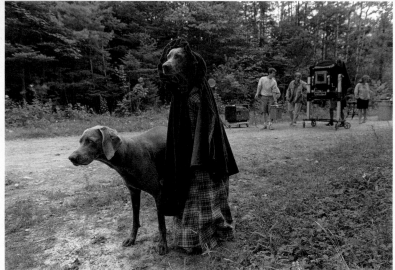

Batty as Little Red Riding Hood (Photo by Madeleine de Sinety)

35mm short, *The Hardly Boys*, starring Batty and her sister Crooky, a parody of the Hardy Boys books (they're girls and dogs...hardly boys) that I had read so fervently in my childhood. These projects brought me closer to the region—both the place and people. My sister's husband, Stan Bartash, a Maine forester who knew everything about the woods, became my personal Maine guide. Stan had access to the region's logging roads and he was instrumental in scouting locations. Another key figure in these projects was Jerome Guevremont, a former Navy SEAL and head of the sewage-treatment plant in the town. Sewage became a key element in the film, along with the abandoned garnet mine he guided me to. These two individuals, through their knowledge and love of the region, deepened and expanded my sense of the place that now permeates my being.

When I think about it, many of the pages that turn up in this book recall my childhood preoccupations, ideas that my higher degrees of education could not displace. Isn't that ironic? And so I continue to work in my studio in Maine. Some days are spent persuing my books, writing, cutting, pasting, painting. Other days I go out with my camera, the dogs, and a few props along for no apparent reason. Just to be on the lake, in the woods, on a trail, just like any other Maine artist.

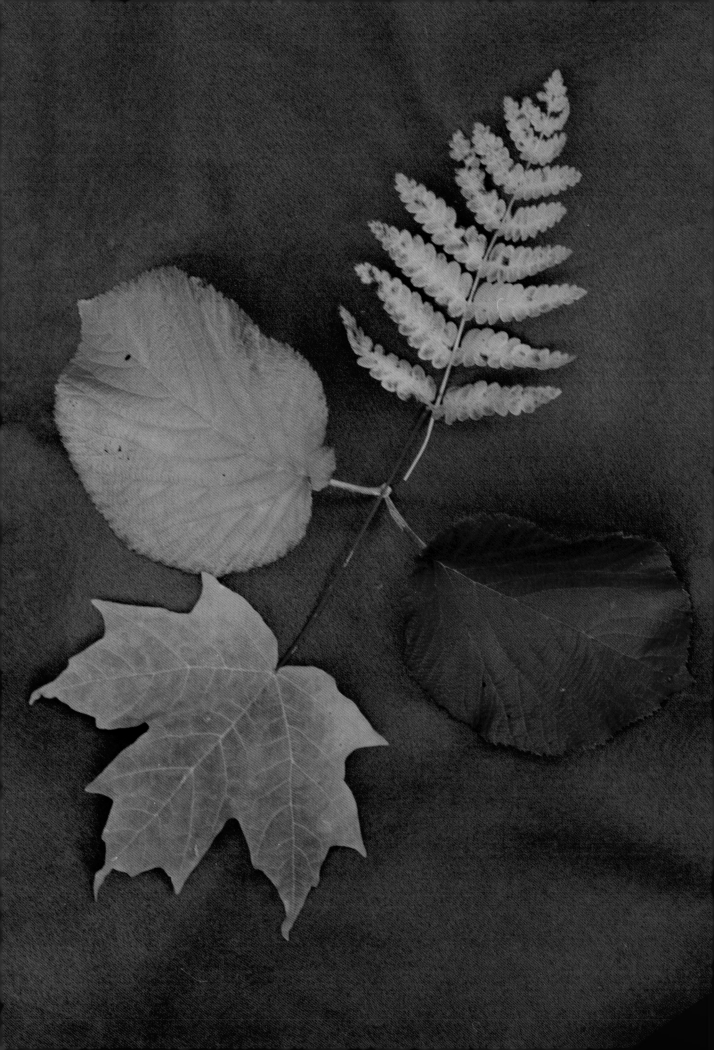

Tell Me Why

WHY DO LEAVES HAVE DIFFERENT COLORS IN THE FALL?

Few adult persons can see nature. . . . The lover of nature is he . . . who has retained the spirit of infancy into the era of manhood.

—Ralph Waldo Emerson, *Nature*[1]

I am never after meaning per se, but sometimes it flickers by.

—William Wegman[2]

Dead or alive, attached or detached, real or fake, leaves are as liberally scattered throughout William Wegman's work as any of the artist's favored motifs. Frequently applied as units of (bogus) classification, they are for Wegman a satisfying metaphor for abundance and variety, metamorphosis and the cycle of life—in a word, Nature—all occult themes in his manic mapping of the world, a world characterized by an insistent cartographic *in*accuracy designed not for *finding* one's way in or out, but for *thinking* one's way around.

To affix, as Wegman has, a plastic maple leaf to the trunk of a tree, or to treat individual leaves as found objects, altered, given voice ("Why, How, When?"), and decoratively arranged above a strangely similar shape that reads, nevertheless, as a bow tie (p. 5), addresses (and parodies) so many things at once (consumerism, modern estrangement from the natural world, ecological degradation, scientific taxonomies, etc.) that the best response is laughter, which Wegman, life-affirming artist that he is, is happy to provoke.

And let's not forget wonder. Wonder threads its way through most, if not all, of Wegman's multifaceted art, not so much a "how did he do that" sort of wonder, although that is certainly an element of the early photo juxtapositions (1970's *Madam I'm Adam*, a disorientingly clever visual palindrome, being a particularly good example of this), but something simpler, more evanescent. *Untitled (leaves on/leaves off)* (1969), another of the early photo diptychs, locates wonder—and comedy—in the ordinary, wherein a tree with its leaves intact is paired with the

same, or ostensibly the same, but now leafless tree. This before/after scenario calls to mind so many fatuous dualities in popular culture (before and after weight loss, before and after plastic surgery) that absurdity and social commentary seamlessly elide, although accompanied, again, by laughter.

The simple wonder of four disparate varieties of leaf apparently growing from the same stem (p. 24) conjures up the practice in seventeenth-century Dutch floral painting of combining in one display flowers that bloomed at different times of the year and could not, therefore, exist together at the same time. This practice was consistent with pre-Linnaean systems of classifying the world while simultaneously celebrating its marvels, duly documented and preserved in cabinets of wonder (*Wunderkammern*, *cabinets de curiosités*) that gathered art and artifacts, nature and culture, in one dense and wondrous space. But such paintings also privileged art over nature, underscoring art's capacity to work miracles.

WHAT IS COLOR?

In Wegman's world, art is constantly working miracles, or metamorphoses, or sleights of hand. Thus, in *Moose Crossing* (1992, pp. 8–9), a two-panel color Polaroid of a cheap, mass-produced wool carpet or wall hanging depicting exactly what its title indicates (a moose fording a stream), the visual pun plays on both the fording and the moose's bifurcation caused by the break between the two panels. The moose thus crosses internally (within the fictive world of the carpet/wall hanging) and externally (across the panel's literal boundary). But Wegman extends the pun further, implying, as his title does, cross-dressing (or rather crossbreeding), a hole having been cut in the actual carpet where the moose's not entirely obliterated head should be, replaced by the real head of Wegman's Weimaraner, Fay Ray, who is thereby transformed, metamorphosed, into a moose. The play of illusion and reality, coupled with a counterpoint of mimicking textures (the carpet's wool, the dog's fur, the moose's faux coat), lends *Moose Crossing*, for all its simplicity, a remarkable degree of visual and conceptual sophistication.

Camouflage is endemic to Wegman. In describing his remarkably dense, playful, and evocative artist's book *Field Guide to North America and to Other Regions*

(1993), he stated that "a lot of the stories in [it] are about disguise and hiding, and that's a basic theme in my work."[3] In the color Polaroid *Camofleur* (1992, p. 2)—the very title of which is camouflaged, combining two French words to create a linguistic form defined by yet another French word, a "portmanteau"—Fay Ray, covered with dead maple leaves, sits before a dun-colored wallpaper. The pattern of the wallpaper, vaguely floral, blends with the leaves to create what in the parlance of natural deception is called countershading, or disruptive coloration, whereby "the normal visual clues by means of which solid objects are recognized as such are lost."[4] This is where Wegman the trickster is at his most effective, for the deception (the camouflage, or crypsis) must fail for Wegman's work to succeed. The goal, in effect, is failure, or at least sufficient tension between success and failure to cause, well, wonder.

WHY DO SALMON GO UPSTREAM TO SPAWN?

But Wegman takes this a step further. In one of his photographs, *Richard Long* (1997, pp. 44–45), which depicts an artfully composed arrangement of mostly khaki-colored rocks, it takes a moment to realize that the sandy surface on which the rocks lie is no beach but, rather, the supine body of a Weimaraner (Fay Ray's daughter Batty). The surprise (shock?) of this realization, accompanied by concern for the dog, arouses a certain frisson. The photograph exists outside of its presence as a work of art to encompass its audience's response. The two—the work of art and the response to the work of art—cannot be disentangled. *Richard Long*, in particular, raises the stakes of Wegman's perennial strategy of concealment. In it, the artist's interest in the perceptual (perception, deception, illusion, disguise, the difference between what we see and what we know) is wedded to notions of attention (the expectation that the viewer is actively looking, is attentive to the hidden) and reception (the awareness that the viewer's reaction will not be neutral). At the same time, in purely iconographic terms, *Richard Long*, so insistently burial-like, becomes a meditation on death.

HOW DID DOGS GET THEIR NAMES?

COCKER SPANIEL

COLLIE

BULLDOG

BEAGLE

DACHSHUND

FOX TERRIER

"Hiding in plain sight" is a Wegman trope, a game equal parts fun and challenging, like a brainteaser or a tongue twister. The "Where's Waldo" ethos that characterizes the photograph *Wood Work* (1991, p. 101) is so obvious that the image becomes a postmodern commentary on the covert while at the same time, in an act of self-conscious historicizing, referencing the nineteenth-century American landscape, Emerson, Thoreau, and transcendentalism. Something slightly similar and slightly different is at work in a photograph from the *Field Guide to North America* (p. 103), which depicts an ostensibly natural, "found" landscape that resembles a dog's profile and is clearly reminiscent of New Hampshire's landmark rock formation, the now-collapsed "Old Man of the Mountain." Wegman's photo is descended from a long line of anthropomorphic (in this case, "skylomorphic") landscapes, visualized in paintings and prints at least as early as the sixteenth century in Europe. In a French image dating to the end of the eighteenth century, a "metamorphosis landscape" simultaneously representing, Arcimboldo-like, a man's reclining head in profile and a verdant hillside dotted with buildings, the accompanying text reads, "Your attempts to view me are vain: / If you perceive me, you will not see me anymore," noting the impossibility of trying to see two things at once.[5] Failure lies at the heart of the endeavor, just as deception's failure is essential to the visual and conceptual success of Wegman's camouflages. The critical difference is that, in Wegman's world, the eye does indeed have the uncanny and paradoxical ability to see two things at once.

Nature is a setting that fits equally well a comic or a mourning piece.
—Ralph Waldo Emerson, *Nature*[6]

In the same elegiac vein as the photograph *Richard Long*, the mysterious, predella-like black strip along the bottom third of Wegman's postcard painting *The Beach/The Sky* (2006, pp. 50–51)—arguably the most conceptually ambitious of his postcard paintings—suggests a dark netherworld below the panel's eponymous beach and sky akin to the attenuated, claustrophobic horizontal of Hans Holbein's famous *Dead Christ*. As with all the postcard paintings, Wegman starts with a real postcard, or several postcards, as the basis for an expanding universe, riffing off its/their contents to invent an ever-growing, crazy-quilt world of multiple perspectives and continuous narrative. *The Beach/The Sky* includes, in fact, only one actual postcard among its apparent ten (not counting the five authentic cards in the cthonic strip below). At near dead center, it depicts the beach at Prout's Neck, Maine, a place so identified with Winslow Homer that the painting inescapably references that artist, his famous studio, and his late seascapes, as do at least three of the real postcards (all rocks and crashing waves) affixed to the black strip, though none of these depicts Prout's Neck.

WHAT IS THE EARTH MADE OF?

It is, however, the nine painted and drawn faux postcards in the panel's upper strata that give *The Beach/The Sky* its particular resonance. Moving beyond the innovation of his initial idea (the postcard as expandable fragment), Wegman, using the postcard instead as a syntactical unit, asks the question: "What, in the history of the postcard as cultural artifact, has been left out, erased, ignored?" He supplies the answer by framing the spaces *between* the things postcards traditionally describe (sky, sand, waves). These pictures of "nothing" draw attention, in fact, to their objectness, their thingness, while also referencing (and parodying) Western painting's historical trope of the window onto an authentically representable world. These subversive little floating rectangles function, then, as allusive meta-documents, both funny and poignant.

Mainers (pp. 52–53), a postcard painting from the same year as *The Beach/The Sky*, functions almost in counterpoint to it, addressing similar issues of signifier and signified (which, frankly, converge in both). Here again, stratification defines the work, divided as it is into three distinct zones. Unlike *The Beach/The Sky*, however, trompe l'oeil dominates *Mainers*, albeit a trompe l'oeil subverted by gigantism. The "real" postcard at the painting's center—the ur-postcard, Wegman world's big bang—forms the basis for a sandwich-board–size "postcard" illusionistically affixed to a panel on which an additional nine (also real) postcards are actually affixed.

WHY IS THE OWL CONSIDERED WISE?

Wegman has noted that viewers tend to lose themselves in "place" in his postcard paintings, fixating on the sites they depict. The artist, instead, deadens himself to place: "for me, it's just shapes and colors. . . There's the linen postcards, the waxy ones, the new ones, the ones with borders. Those are my problems, not the place."[7] Yet this attention to object, not subject, can only go so far. The postcards (a form of readymade) function as found text. As such they replace Wegman's self-conscious texts—those accompanying his photographs and drawings—which depend for their full effect on the punning collaboration between text and image. Subject cannot be willed away in the postcard paintings; it intrudes too forcefully.

Labeling, naming, and mapping dominate the postcard paintings, as they dominate so much of Wegman's nature imagery, though almost always in ways designed to confound. While the early drawing *Landscape Color Chart* (1973, p. 40) labels its components ("blue, yellow, green") with an apparent but misleading literalism (again eliding signifier and signified), the postcard paintings label, name, and map

with an apparent but misleading symbolism. Their readings are contingent, determined both by the (planned) arbitrariness of their making ("for me it's just shapes and colors") and by the random associations every viewer harbors.

Wegman's delight in naming, classifying, and mapping things stems from his early interest in texts such as the *Book of Knowledge* and similar compendia of the natural world. Expanding on this, he explains, "I have always been interested in nature and nature writings in particular, especially when it comes to clashing concepts of nature—American transcendentalism, the Boy Scouts, *Field and Stream* magazine, new age musings, nature scrapbooks, etc."[8] This emporium of information—scientific, philosophical, recreational, and goofy—forms the foundation for the similarly (pseudo-) scientific, philosophical, recreational, and goofy in Wegman's art, all rolled together in a manic, exhaustive, and exhausting quest to describe the world. One is reminded, in Wegman's encyclopedic and disjunctive list making, of transcendentalist Henry David Thoreau, whose description of the Maine wilderness intones as follows:

[A] country full of evergreen trees, of mossy silver birches and watery maples . . . with innumerable lakes and rapid streams peopled with trout. . . , with salmon, shad, and pickerel, and other fishes; the forest resounding . . . with the note of the chicadee, the blue-jay, and the woodpecker, the scream of the fish-hawk and the eagle, the laugh of the loon, and the whistle of ducks . . . , with the hooting of owls and the howling of wolves; . . . swarming with myriads of black flies and mosquitoes, . . . the home of the moose, the bear, the caribou, the wolf, the beaver, and the Indian.[9]

WHAT IS GELATIN?

In its natural and unspoiled beauty, the Rangeley Lakes region of Maine—where Wegman has spent part of every year for more than three decades, where so much of his nature-inflected work has gestated, and where his first mature painting was born, in 1985—comes as close as any quarter of Maine to Thoreau's description from 1846. The inherent goodness the transcendentalists believed resided in man and nature runs like a slow curling stream through Wegman's art, just as the theme of love (the secret to his popular success) is its essential subtext. As Wegman has said: "I don't really know what it all comes out to. I know I'm basically a painter . . . and that my total warmth, love, and desire in being an artist is rooted in that . . . But I have a most delectable sidetrack—really a love affair with the dogs—that I make no attempt to deny."[10]

The moment of greatest poignancy in Ovid's story of Diana and Actaeon occurs when the hunter realizes that his beloved dogs no longer recognize him, seeing, as

they do, only the stag into which he has been transformed by the wrathful goddess. Before this metamorphosis, Ovid scrupulously names Actaeon's many hounds, thus underscoring the love their owner feels for them and maximizing the tragedy of the story's conclusion, when Actaeon is destroyed by the very creatures he loves and who love him. The beauty of William Wegman's art is that his woods hold no malign Diana, only Actaeon and his devoted hounds enjoying a perfect summer's day under a perfect summer sun.

—Kevin Salatino,
Director, Bowdoin College Museum of Art

WHAT IS CAFFEINE?

Notes

1. *Ralph Waldo Emerson: Essays and Lectures* (New York: Library of America, 1983), p. 10.
2. M. Walsh and R. Enright, "Chameleonesque: The Shape-Shifting Art of William Wegman," in *Border Crossings* 22 (Feb. 2003), p. 31.
3. Ibid., p. 31.
4. H. E. Hunton, "Natural Deception," in *Illusion in Art and Nature*, R. L. Gregory and E. H. Gombrich, eds. (New York: Scribners, 1973), p. 98.
5. B. Stafford and F. Terpak, *Devices of Wonder* (Los Angeles: Getty Research Institute, 2001), pp. 248–51.
6. *Ralph Waldo Emerson: Essays and Lectures*, p. 10.
7. Walsh and Enright, "Chameleonesque," p. 47.
8. J. Simon, *William Wegman: Funney/Strange* (New Haven and London: Yale University Press, 2006), p. 168.
9. "The Maine Woods," in *Henry David Thoreau* (New York: The Library of America, 1985), p. 653.
10. Walsh and Enright, "Chameleonesque," p. 47.

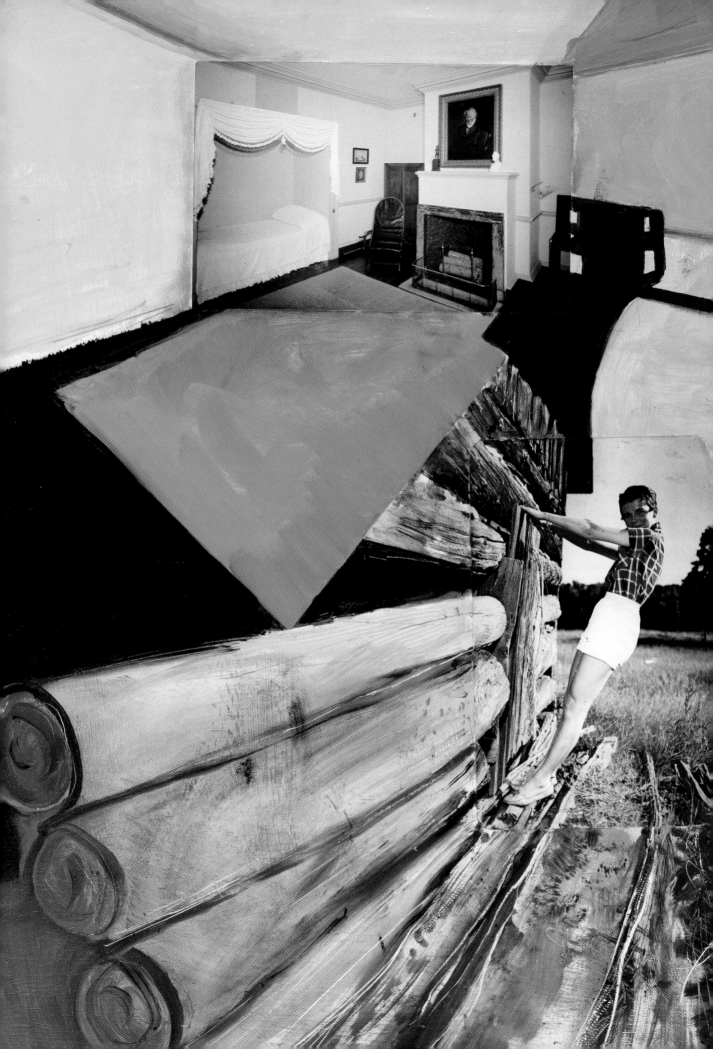

Room with a View

A TRIP ACROSS

Take a look through these pages
and you will see many things
that you can find
as you travel across the land.

You will walk down a road,
cross over a bridge,

go through a tunnel,

THE LAND

and come out in a land
of lakes,

a land of
shifting sand,

a land of canyons,
a land of gorges,

a land of mountains,
a land of cliffs,

a land of rain forests,
or a land of swamps.

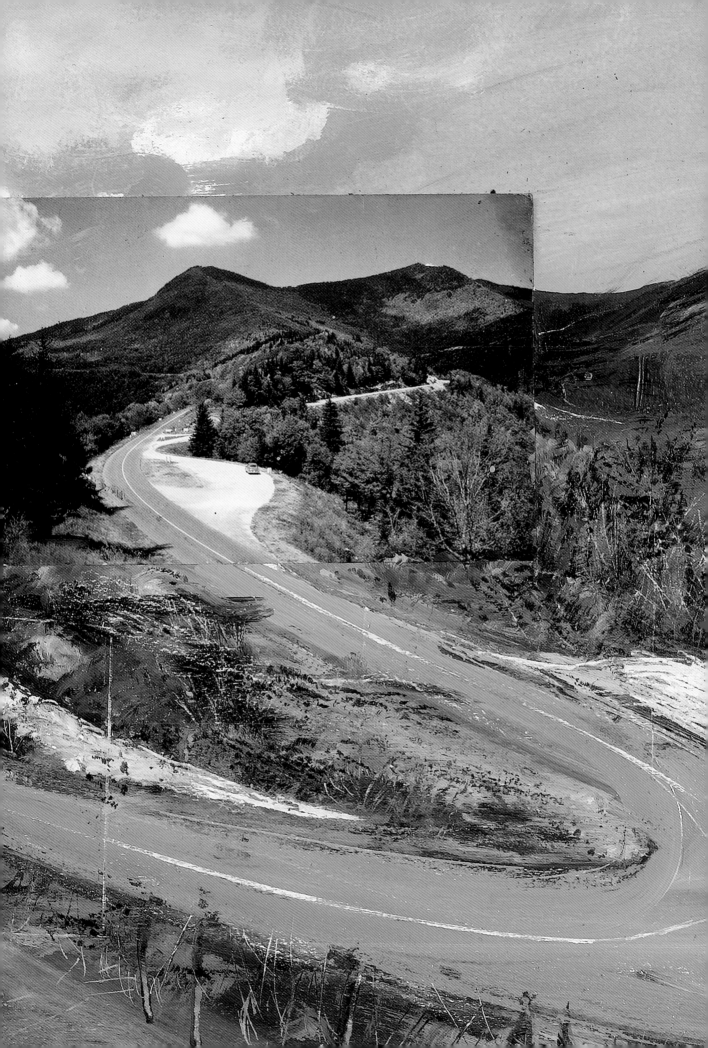

blue

yellow

green

landscape color chart

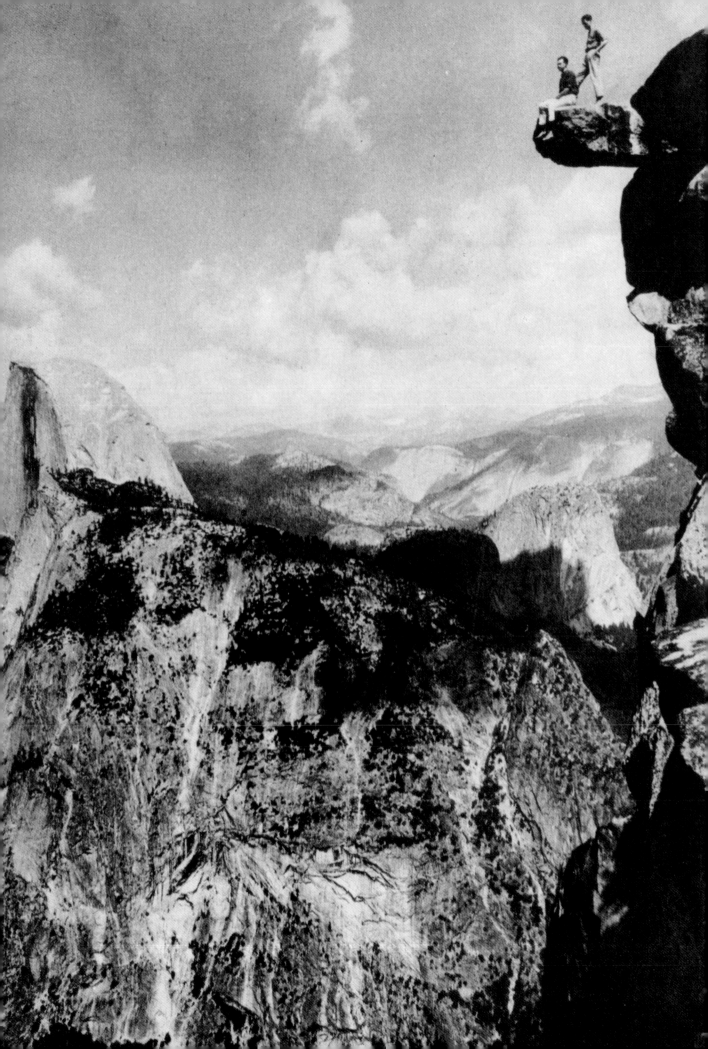

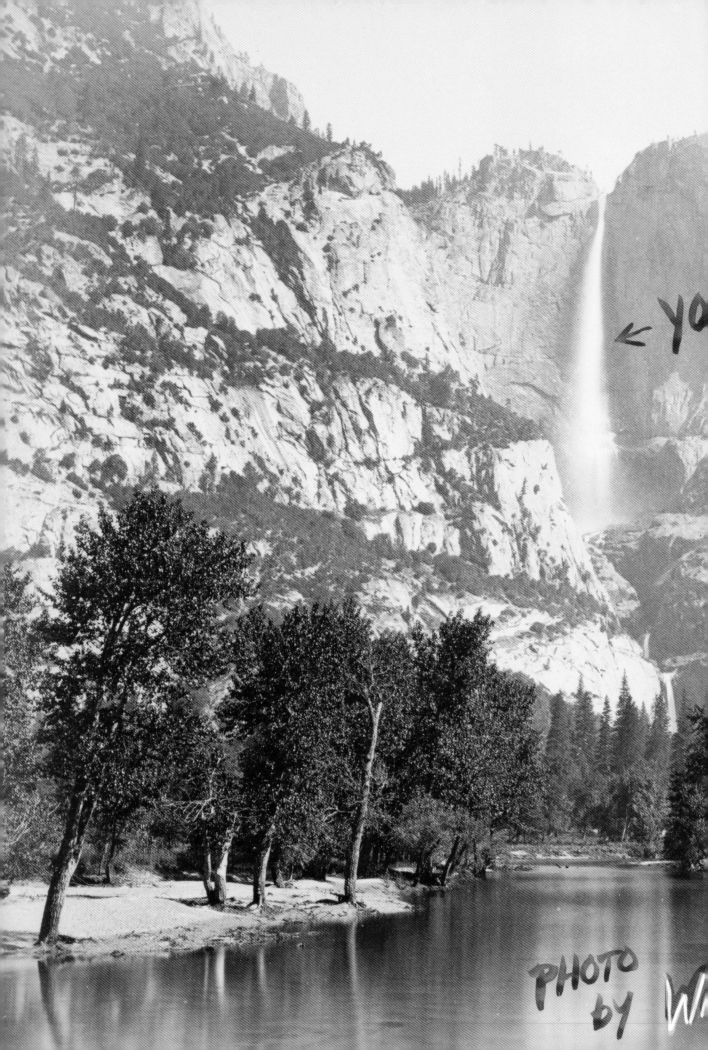

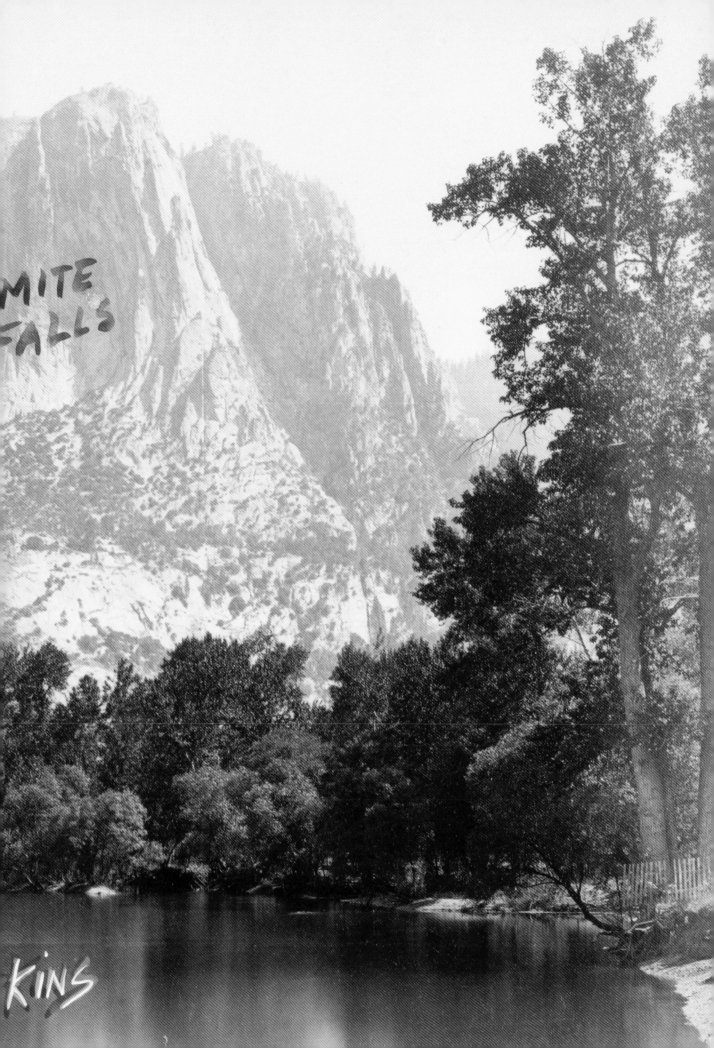

I see a mushroom.
But it is not a mushroom
that I can eat.
It is really just a rock
that looks like a mushroom.

Stone Mountain, Georgia

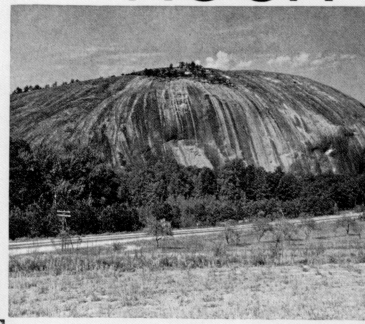

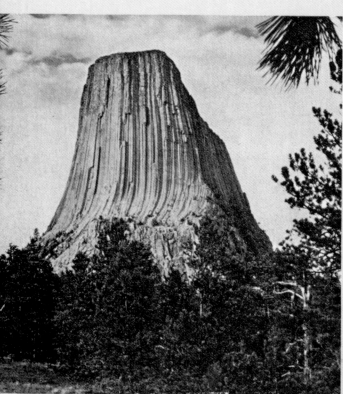

I see a monstrous tree trunk.
But it is not a tree trunk
that I can chop.
It is really just a rock
that looks like a tree trunk.

Devils Tower, Wyoming

I see a castle.
But it is not a castle
that I can play in.
It is really just a cluster of rocks
that looks like a castle.

Bryce Canyon, Utah

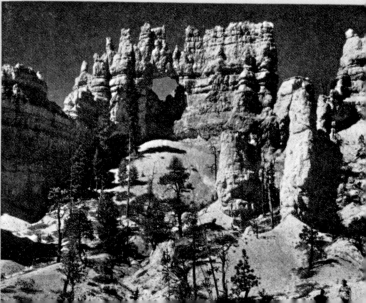

PICTURES

I see some skyscrapers.
But they are not really skyscrapers!
They are really just cliffs
that look like skyscrapers.

El Morro, New Mexico

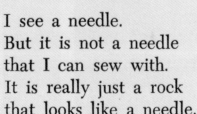

I see a needle.
But it is not a needle
that I can sew with.
It is really just a rock
that looks like a needle.

Needle's Eye, North Dakota

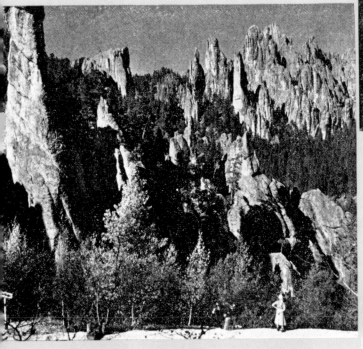

I see a man's face.
But it is not a face
that feels soft when I touch it.
It is really just a rock
that looks like a man's face.

Wind and rain carved them all.

Profile Mountain, New Hampshire

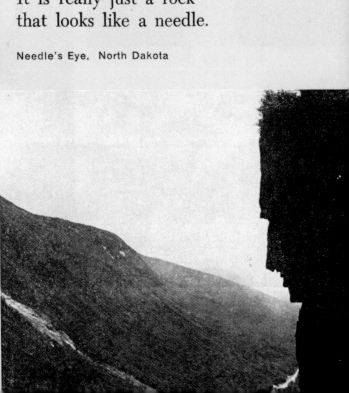

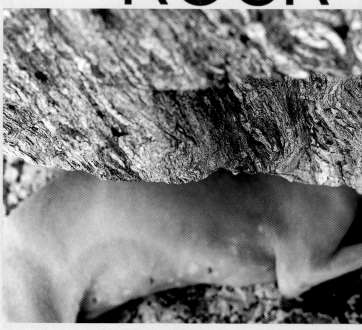

I see a mushroom.
But it is not a mushroom
that I can eat.
It is really just a rock
that looks like a mushroom.

Stone Mountain, Georgia

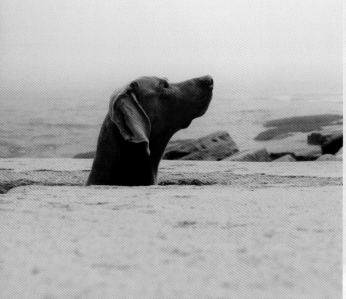

I see a monstrous tree trunk.
But it is not a tree trunk
that I can chop.
It is really just a rock
that looks like a tree trunk.

Devils Tower, Wyoming

I see a castle.
But it is not a castle
that I can play in.
It is really just a cluster of rocks
that looks like a castle.

Bryce Canyon, Utah

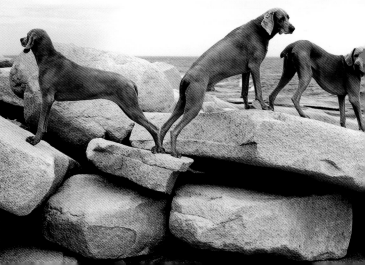

PICTURES

I see some skyscrapers.
But they are not really skyscrapers!
They are really just cliffs
that look like skyscrapers.

El Morro, New Mexico

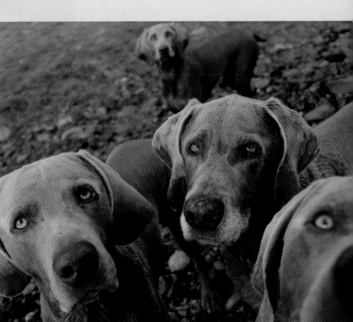

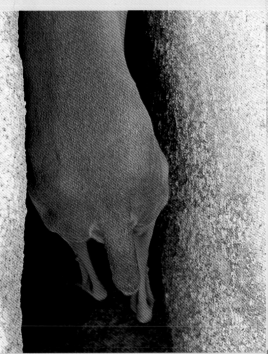

I see a needle.
But it is not a needle
that I can sew with.
It is really just a rock
that looks like a needle.

Needle's Eye, North Dakota

I see a man's face.
But it is not a face
that feels soft when I touch it.
It is really just a rock
that looks like a man's face.

Wind and rain carved them all.

Profile Mountain, New Hampshire

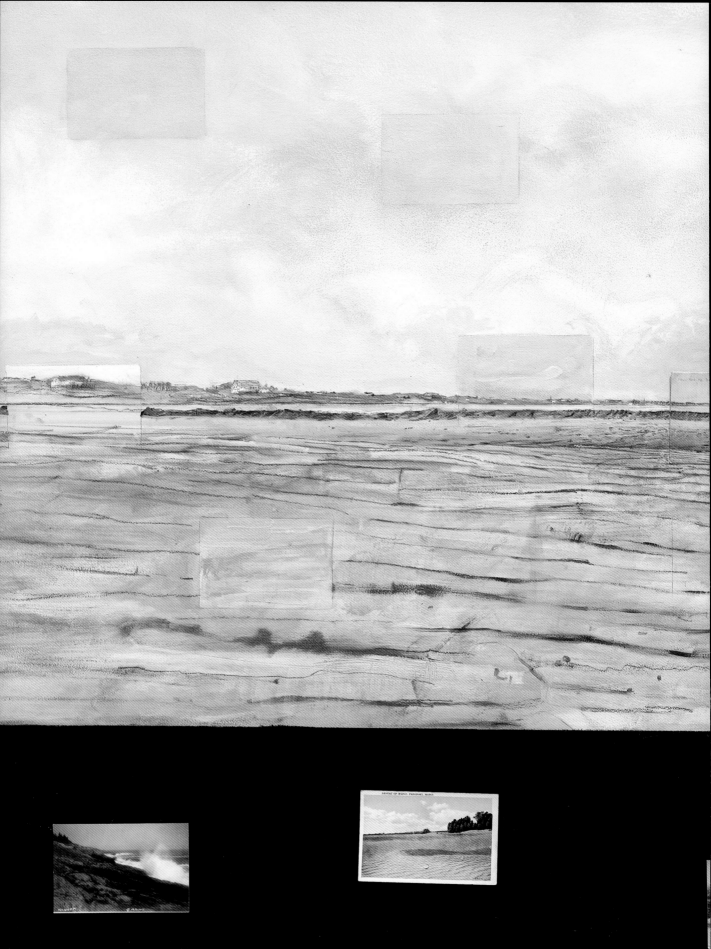

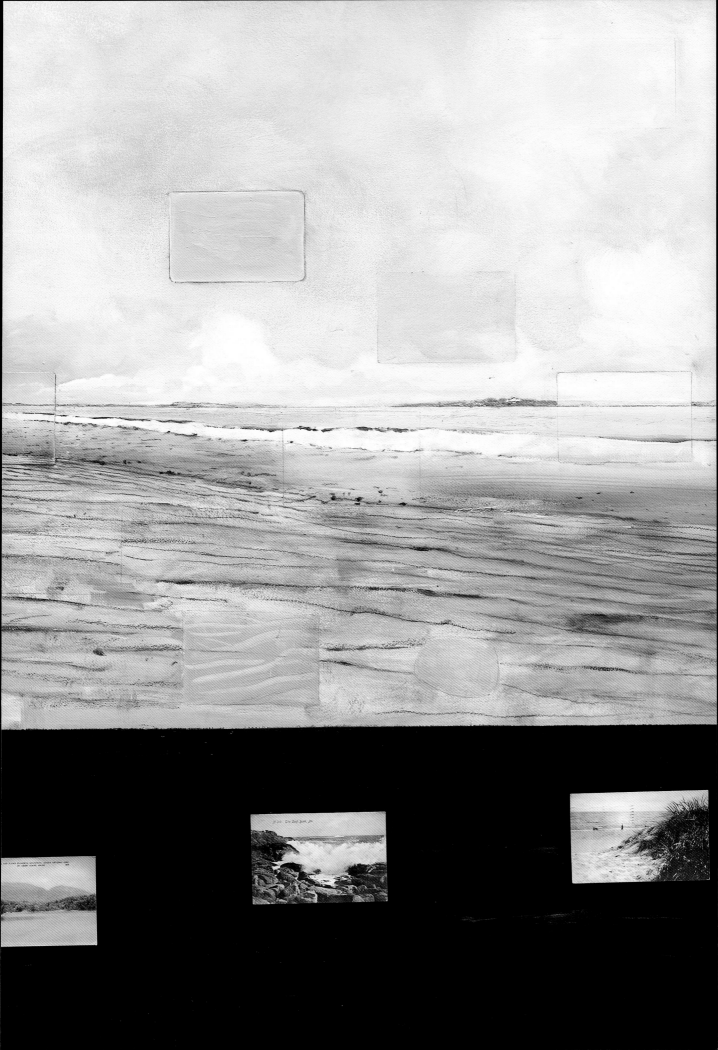

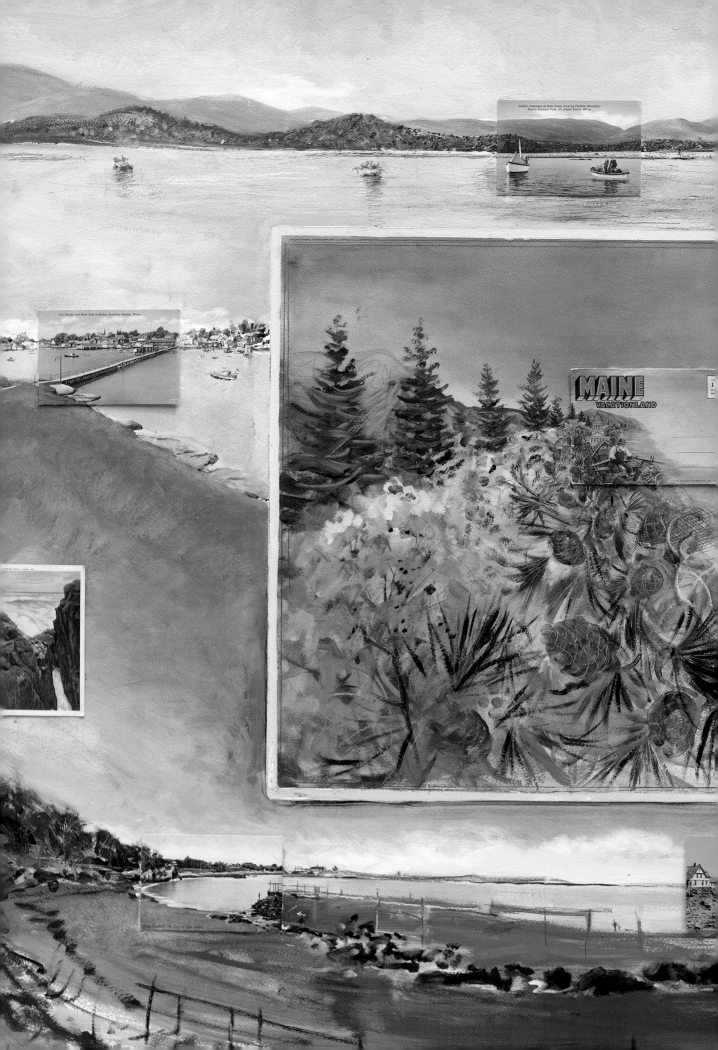

MAINE
VACATIONLAND

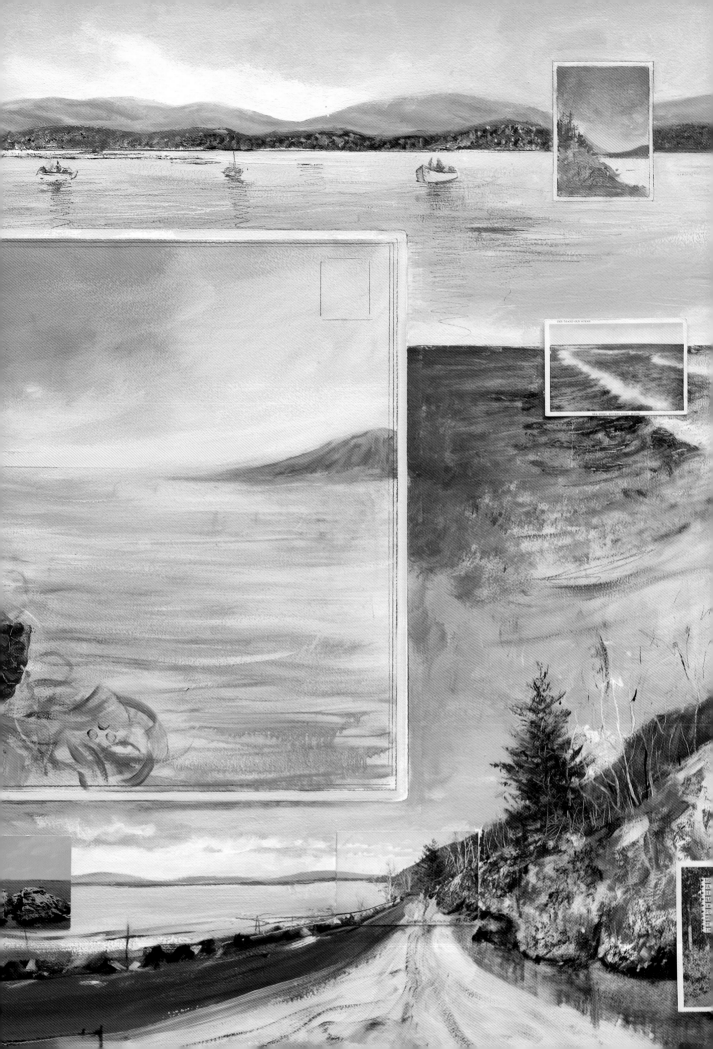

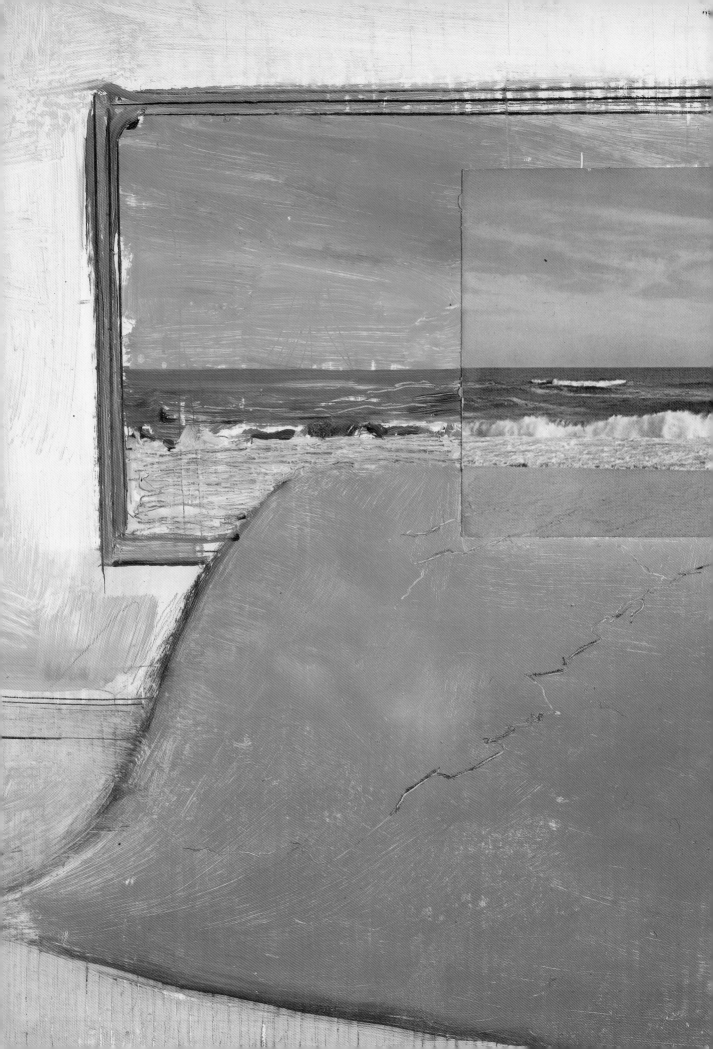

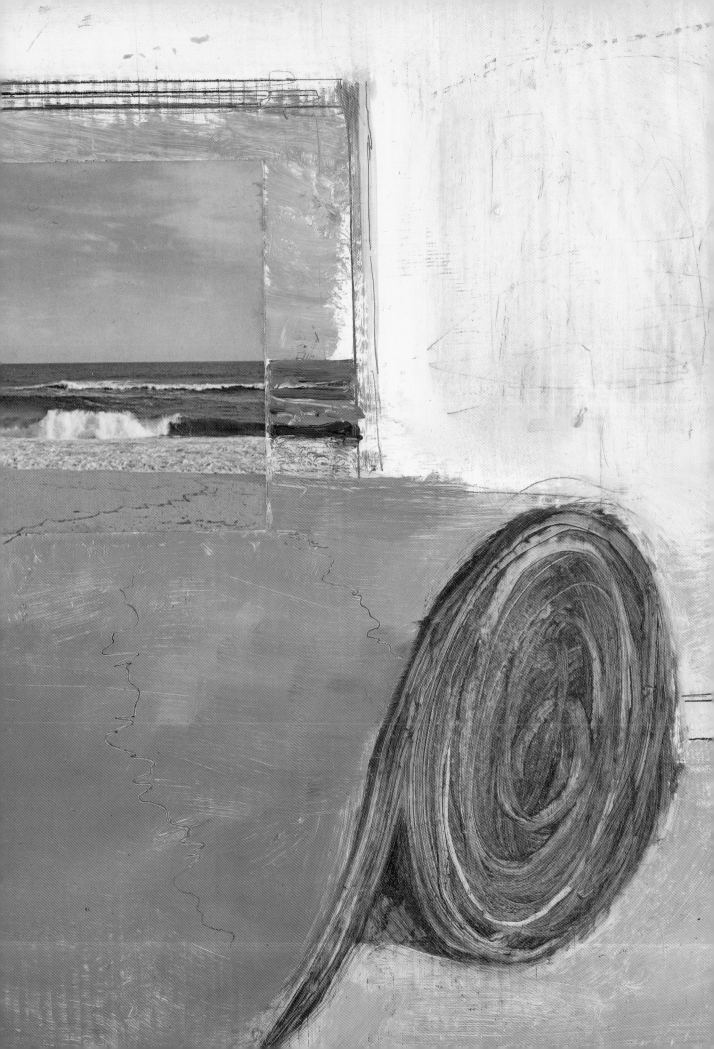

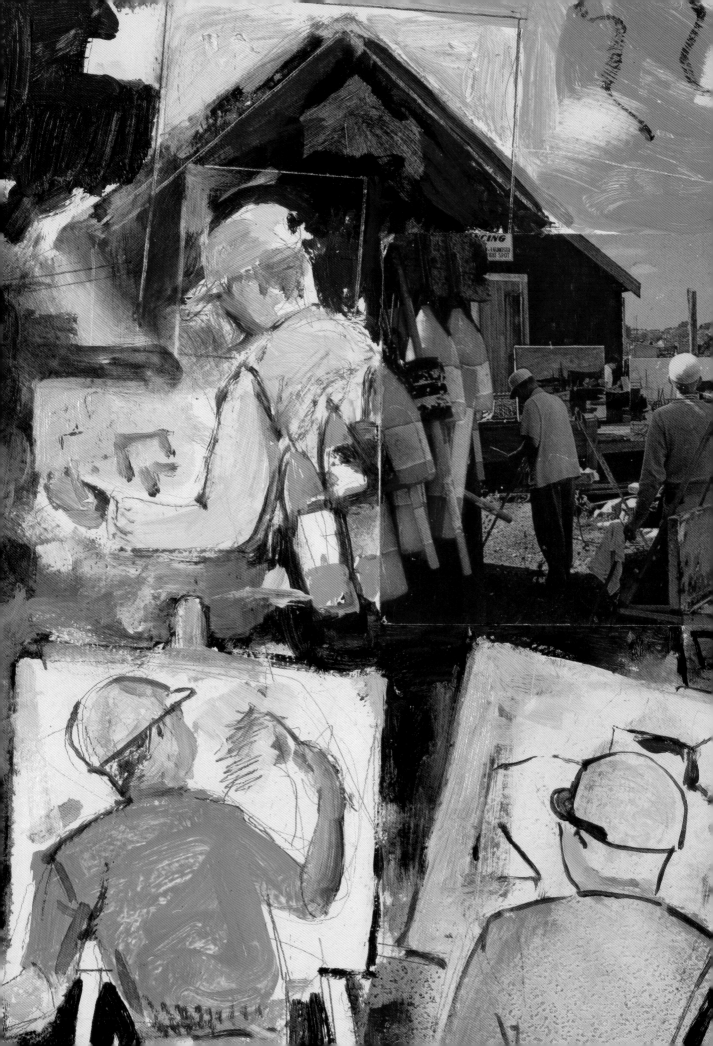

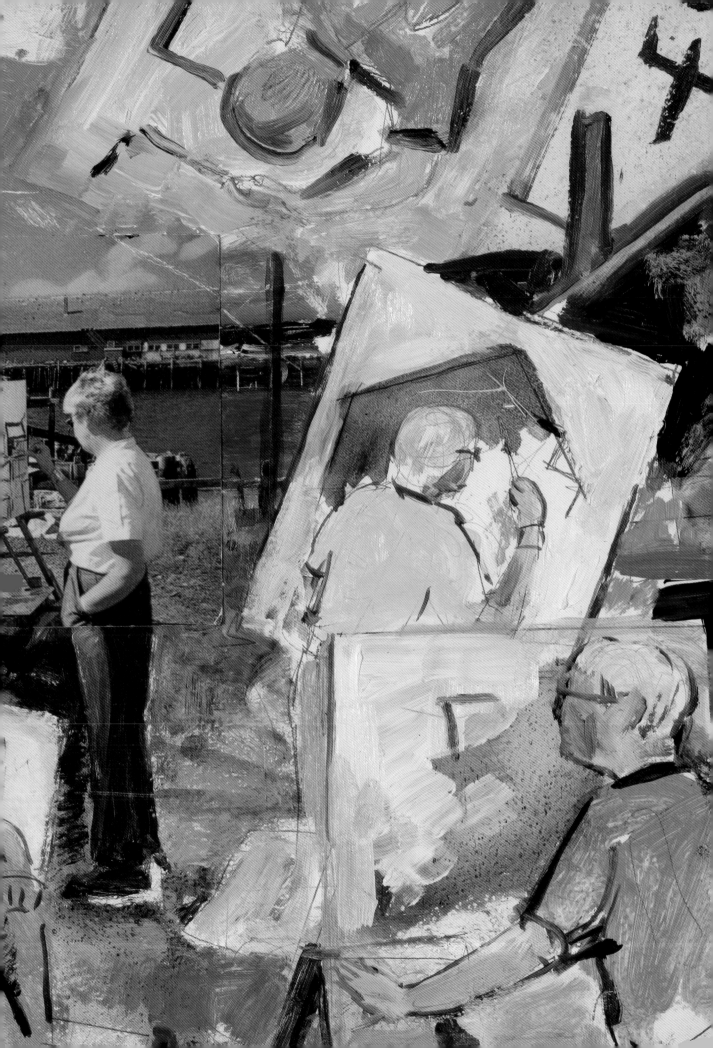

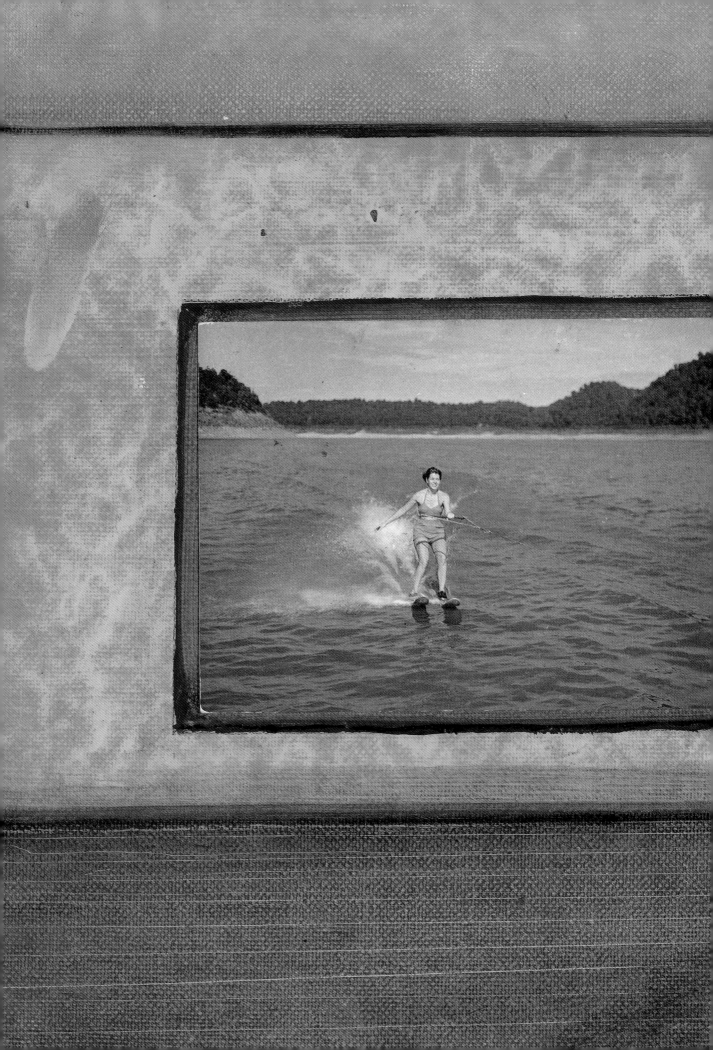

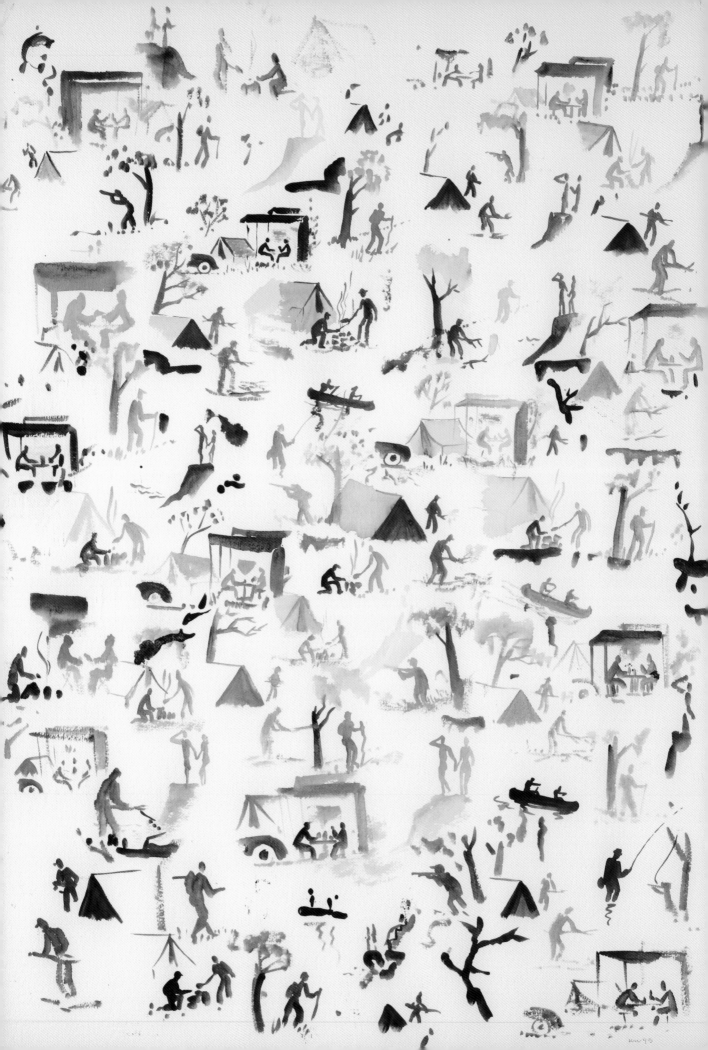

Family Camping

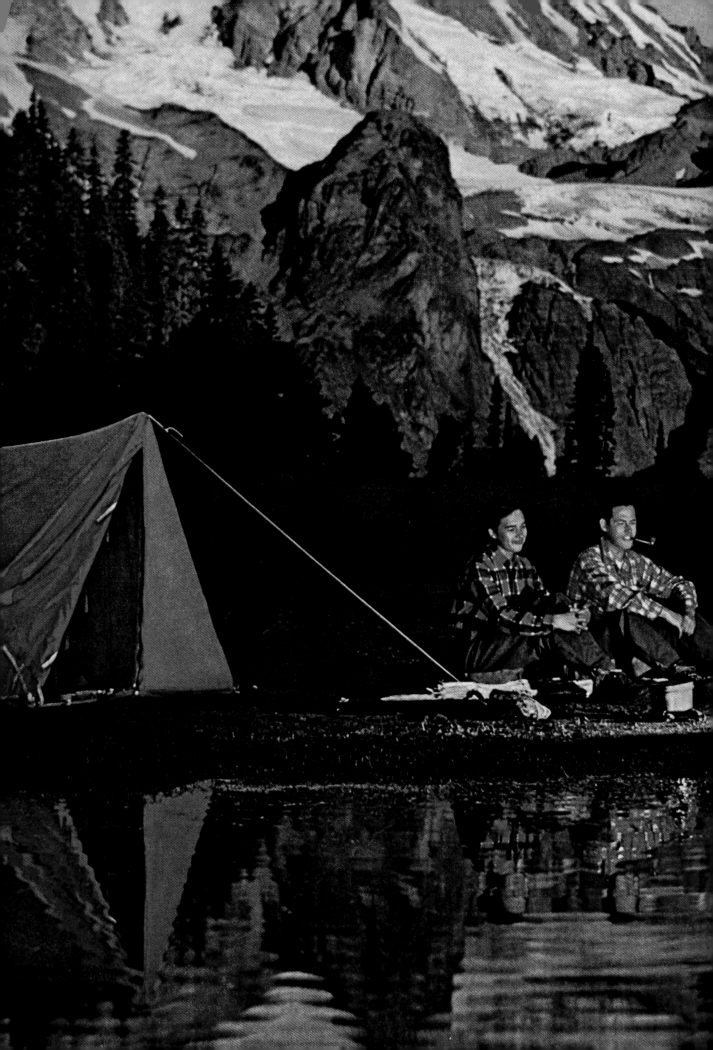

The first time I saw Bill Wegman, I think, I was on a porch over a lake in Maine at dusk and a fellow came paddling by in an aluminum canoe trolling a fly. I called to invite him up for a drink and was violently shushed by the people on the porch drinking. *He doesn't drink anymore*, it was imputed to me, and the implication obtained that his not drinking was a matter of such delicacy that were I to tempt him in the way I had Bill Wegman could be ruined. In this quiet corrected air on the porch I watched the interesting lone figure of Bill Wegman continue on his troubled way untroubled. He was wearing a funny-looking kepi with flies pinned to it and was sitting in the rear of the canoe. His weight tipped the front of the canoe way up in what is called, now, by me, the weather-vane configuration of canoes. Any woodsman is familiar with the weather vaning of a canoe: the bow will swing downwind and you will go nowhere but downwind, if there is a wind. But there was no wind on Loon Lake and Bill Wegman went forward, having perhaps waved at me and my bad idea. The woman who had remonstrated the most against my hospitality had the largest breasts I had seen on a live human being and I

would later learn that she had taken a man away from a friend of hers once, and the friend had, in revenge, flashed her own breasts at the large-breasted woman and screamed "They're *real!*"

The large-breasted woman and the normal-breasted woman had been friends and waitresses some thirty years before at York's Lodge, a log affair so large that it had accommodated in the day the restaurant they worked in, a laundry, a lobby full of mounted big-game heads, some not from Maine, a fireplace a child could walk through without stooping, a boiler room, a library, a sitting porch facing the lake, a sitting porch not facing the lake, and even a machine to wash change, the kind of touch you hear about famous hotels in San Francisco having. The Lodge had served some fifteen or twenty cabins around it where the guests who ate at the restaurant and marveled at the animal heads and lounged and had their change washed stayed, and they were provided a newspaper and a fire in the mornings in these cabins by a boy. It was halcyon. By the time I saw any of it, it was gone. The Lodge was closed, the waitresses were flashing each other as old women, the sign in the Lodge that read No Jews

or Consumptives was offending no one, if it ever had, and the cabins had been sold off to individuals.

Bill Wegman at this point owned one of the cabins, called Sunset, in which he had photographed two Weimaraners in bed and called the photograph *Ray and Mrs. Lubner in Bed*. The close cabin and the cozy bed and the heavy bold plaid blankets and the logginess of everything, walls and furniture alike, were altogether so Maine-woods that even the perversion of two dogs looking like a happily married bourgeois couple in bed could not undo the Maine-woods kitsch. The Maine-woods kitsch in fact was enhanced by these goofing, Kinseyan dogs in bed. The Maine-woods kitsch, in fact, was no longer kitsch: these dogs in this bed made you want to be in the bed, own the cabin, be precisely in Maine, possibly even be part of a happily married bourgeois couple in Maine. Were anyone else to put his dogs in bed it would look like dogs in bed. How did these dogs put there look like, well, something that had meaning? Who was this Bill Wegman dude?

Bill and I sat at the chipped white-enamel metal table in the kitchen of Sunset. I was in the fevery tremble of a hangover and I brought up the subject of my having invited his ruination by inviting him to have a drink so imprudently the other night as he

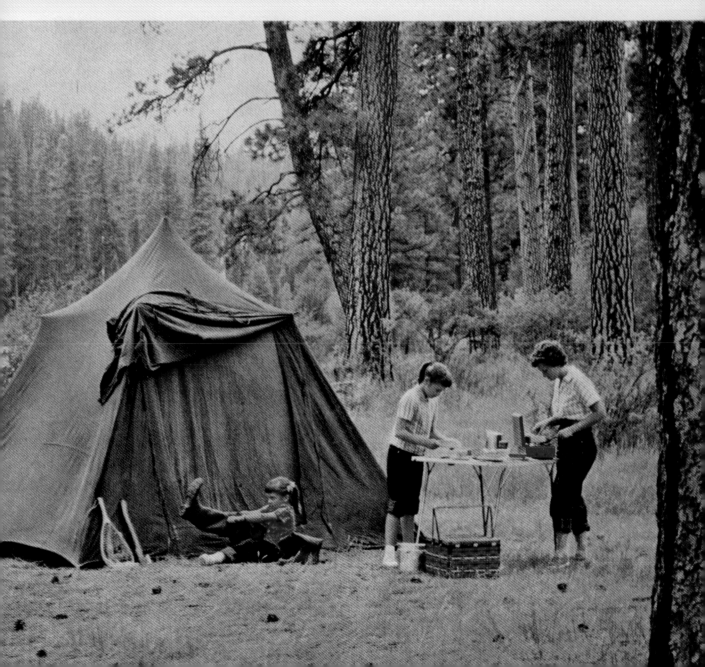

weather-vaned by. Bill might have smiled. He told me that he had gone to Memphis once very drunk and remembered everything, and he had gone to Memphis sober and remembered nothing. This was just one of the sad ironies of living on the planet without booze. Bill did not say "the sad ironies of living on the planet without booze"; I thought it, trying to size up what the planet would be like as I steadily prepared to have to live on it myself. I was resisting the move. Bill said it was actually more fun after you made the move. Another improbable idea. Bill got on a Bakelite phone with a rotary dial and called a woman in New York, his girlfriend-assistant, and said, "Bring up a tube of that good red paint. What? A big one." He got off the phone and said two women were going to visit and he'd had relations with both of them and this had never happened before and it might be weird. Ray and Mrs. Lubner's bed was right over there, and there was no other bed, and I had to agree. I thought maybe this Wegman dude was too New York for me, maybe too Paris. But he sounded like he was from California, or nowhere at all. And he was not going to utter the phrase "sad ironies" without more or less figuring out how to get a dog to say it. This much I knew so far.

So far I have intimated that I came to know Bill Wegman in a knowing, demonstrable, orderly, coherent, memorable way. I have been lying, and the exhaustion of lying now suggests I relax and just say a few things and admit that the things I have already presented are bogus. The waitresses that worked in York's Lodge did in fact get in a fight over a man and the one who wore thick cat-eye glasses that she pushed up on her nose to keep them there who had lost the man did in fact show her breasts to and scream at the woman who stole the man. I sat at a table in Sunset when Bill ordered a big tube of red paint, but probably months, or years, after the shushed invitation to have a drink. And so forth. Once Bill Wegman and his painter friend David Deutsch walked into York's Lodge when it was still active and read the sign that said No Jews or Consumptives, and David is Jewish and the woman with him had tuberculosis, and David and Bill thought the scene was funny. The two of them had played around in Maine before Bill had reached the stage where he could acquire property, and of this time Bill once said, "I was a complicated, messy person."

By the time I heard this I knew it was part of what we will call, very unWegmanly, the Wegman aesthetic. Complicated, even messy, ideas can be stated so simply that they have the sudden, surprising quality of truth, even if they are false. This is, to my mind, more or less what Bill Wegman is about. I'd rather not have to try to prove this right now, or give an example. Here's another stab at the idea: Bill Wegman takes oaf to the second power, where it is not oaf, and part of the way he does this is via line art as strong as that of Picasso and his bulls. Let's move on.

Maybe soon after I saw Ray and Mrs. Lubner and entertained my ideas about the planets Booze and Nobooze, etc., I saw a huge black-and-white photo of Bill's of a woman with a muscular back poised to throw a large tray, discus style. She looked like Arnold Schwarzenegger's sister if you are prepared to believe Arnold Schwarzenegger has a sister and that she'd be attractive. I probably received the notion (or made it up) that this woman was the girlfriend-assistant, or a previous girlfriend-assistant, or one of the relations-with women, and decided that Bill Wegman was not too New York or Paris for me but too *Tangier* if he's running with Schwarzenegger's sister and she's throwing Moroccan brass platters around nearly naked—this Wegman is an alpha dog, get away.

But Bill kept showing the oaf card. The GAP, I think, was going to come up and

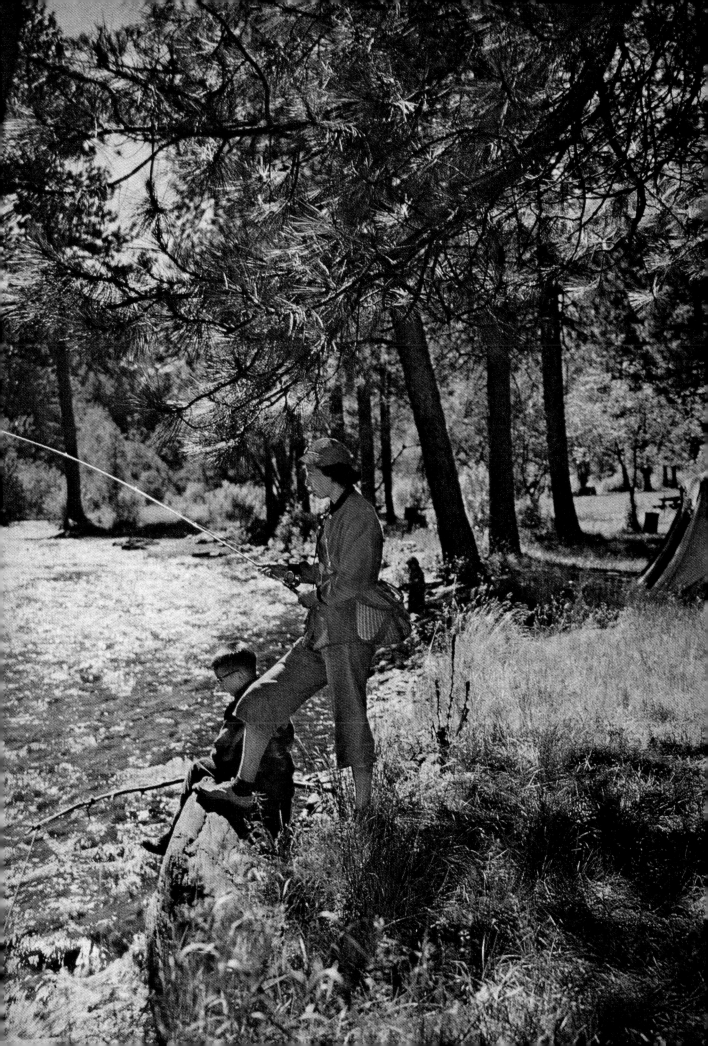

do a commercial with him in it; they were calling to see what size clothes to bring for the shoot. On the phone—now a mobile phone, on the porch of the Lodge, which he now owned—Bill said, "Me? I'm four-foot-nine and weigh four hundred *pounds*." Another time he had consulted a doctor about pain in his lower back and the doctor, after ordering some X-rays, had come in and said, "I think we can rule out bone cancer." Bill was affronted by the indelicacy of the doctor's approach, and he said, "He came in and said, 'I think we can rule out BONE CANCER' "—virtually yelling *bone cancer*, the way he had virtually yelled *pounds* at the poor GAP girl. This is the technique, except here it is verbal: one word, one heightened word. In drawing and painting, it becomes one line, one correct line, that does the work, the unique perfect meaning making. Bill can find the line.

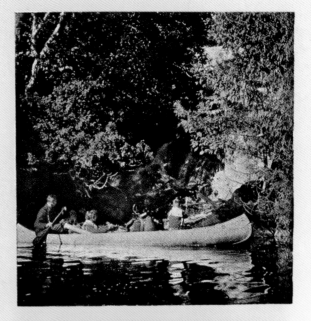

In all the dog stuff, he found the line by finding the *ur*-dog, the purest dogness of all the hundreds of breeds of dogs in the gray, elegant, unaffected, clean lines of the Weimaraner. I told Don Barthelme once that I had met Bill Wegman, asked what he thought of him. "Pretty good, but then the damn dog died." Bill ran around with John Belushi, and Belushi would taunt him, "Wegman! What you gonna do when the dog dies, Wegman!" When the dog died Wegman began breeding dogs.

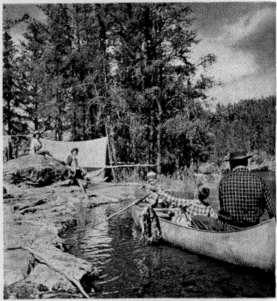

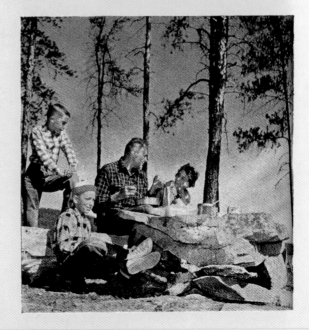

So Bill Wegman over time went from one dog to five, six, seven dogs; from one cabin to that cabin, the Lodge, the tennis court, and the two houses opposite the Lodge; from one girlfriend-assistant bringing up a tube of red paint to a Ryder truck that spills out four people on payroll and Klieg lights and cameras to make a movie, to include a grip who can make a regulation tennis-umpire chair in a day and paint it the proper green. The last time I was in the studio they were deciding among designs for dog-print fabrics. It's an industry.

Yet it is not. You can still walk into the studio in Maine and find Bill playing around with postcards, positioning them on a board in order to seamlessly link them with a paintbrush and paint, some of it red paint. Bill can paint. He can very paint. I am past being struck by Mrs. Lubners and dogs with elephant trunks on them and flour dumped on them *perfectly* but I am not yet past the painting. That's what you want to see. Ask to see the damned thing that was walked on on the floor to prepare it—what do they call doing that?—that is based on little wild animals in Mexico. Or, I don't know, has maybe one wild animal from Mexico in it. Or has a fox, maybe just a fox, maybe it's a bat. Maybe I am confusing the painting with a little booklet called *Wild Animals of Mexico* I saw near the painting. Bill can paint.
 —Padgett Powell

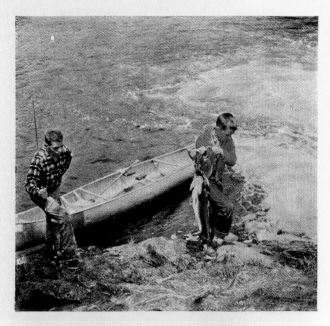

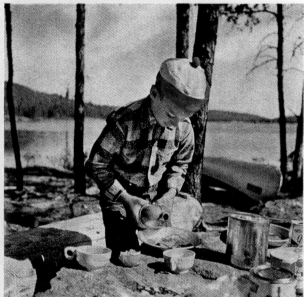

A Field Guide

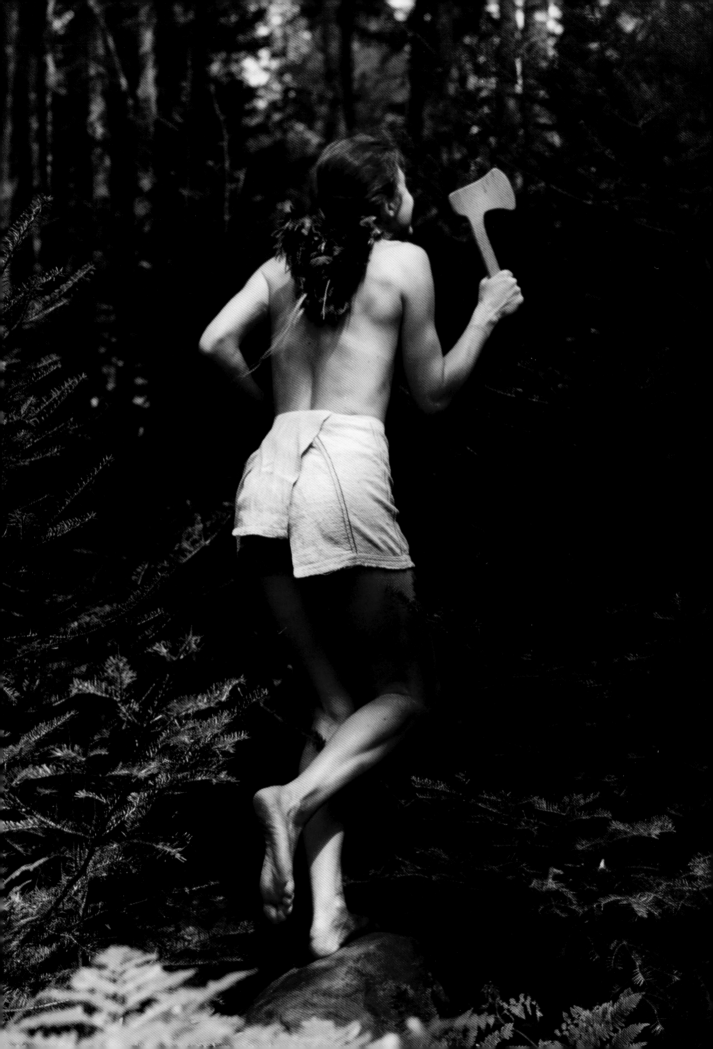

Man is doing all he can at an alarming rate to destroy the environment. In his or her vain attempt to make products which will make her life more easy or that will satisfy his predatory nature man is rapidly using up her natural resources. Soon there will be no forest for him to forest ~ no forest left. Nothing. Nada! to farm producing nothing. left for man to cultivate. This may not necessarily be bad! shown whenever man becomes down within himself, he comes through with a brilliant and timely solution. Men and Women thrive on crises.

With trees as with humans both are male and female but not in obvious ways. From a distance they may look al[ike]. bark, leaves and branches may be the same. you will notice on the poplar for The female has long slender catkins whereas the male has dark purple ones. Trees when transplanted should be selected from a nursery or the forest when young. Sexuality between the trees is an amazing site to observe. the. Few have witnessed the shimmering beauty of arboreal conjugalation.

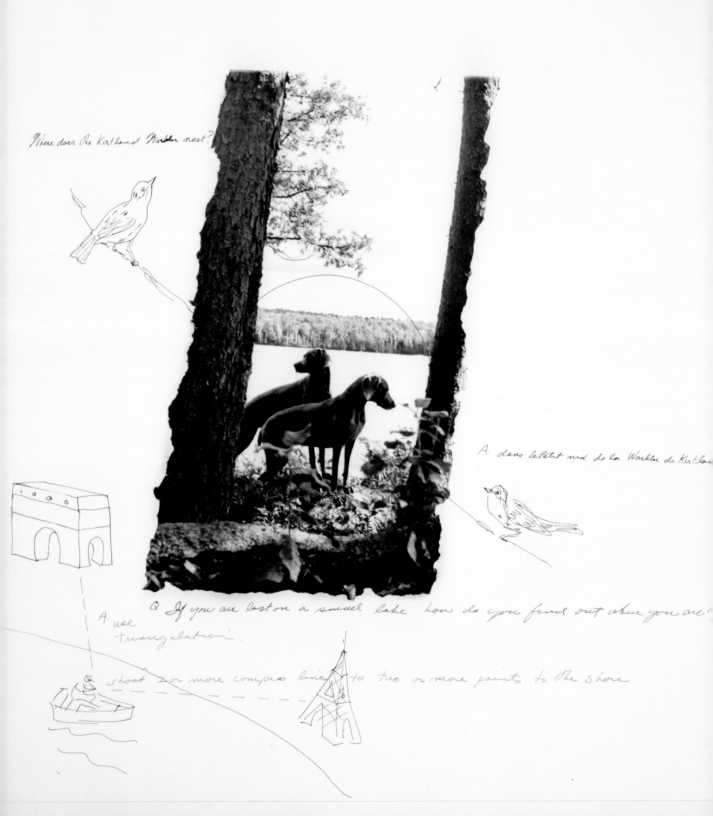

Where does the Kirtland Warbler nest?

A. dans le Petit nid de la Warbler de Kirtland

Q. If you are lost on a small lake how do you find out where you are?

A. use triangulation.

shoot two or more compass lines to two or more points to the shore

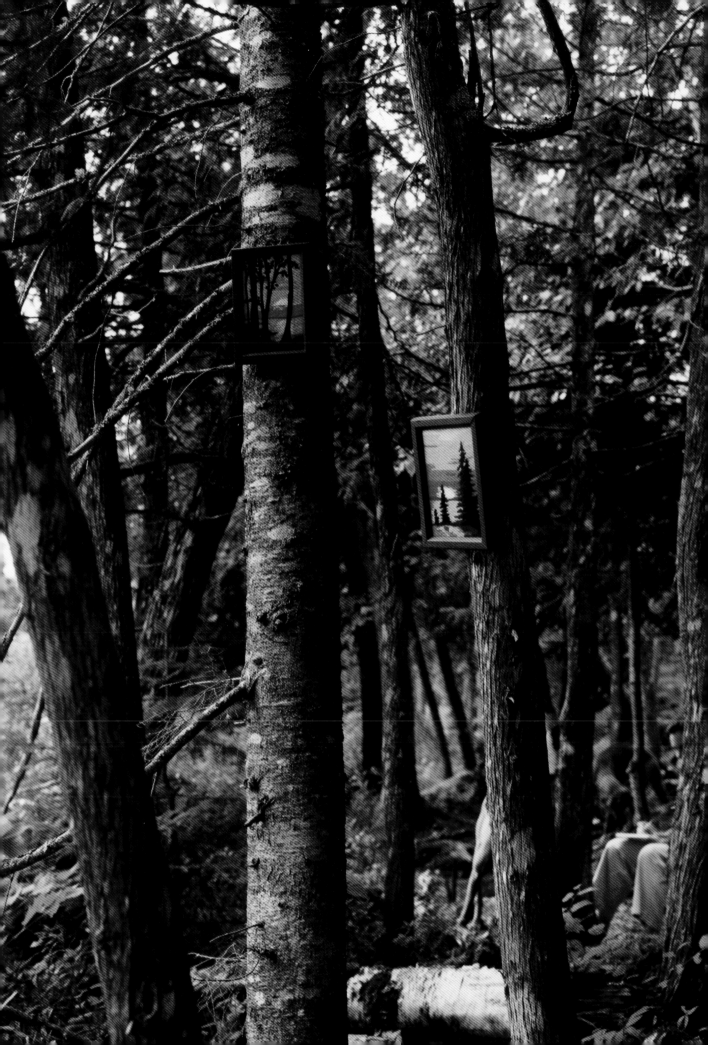

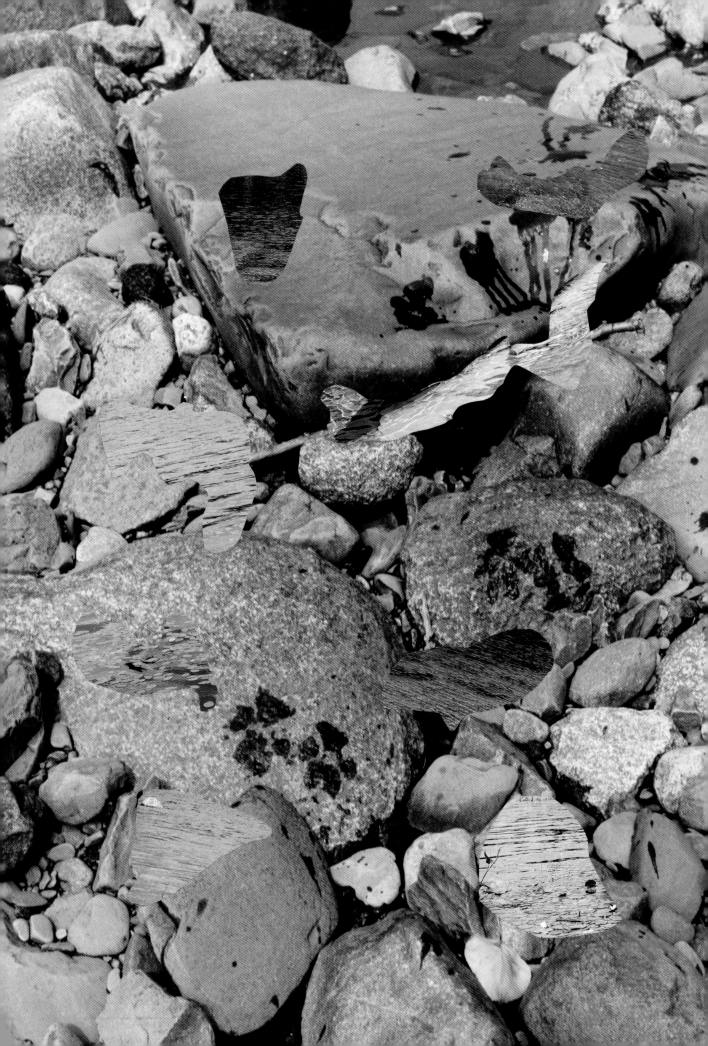

now retirement community

Canada

New York

101—The Presidential Range and Israel River, White Mountains, New Hampshire

New Hampshire

MT. PICO, GREEN MOUNTAINS OF VERMONT 50GM

now a high school
soccer field

303 miles

Massachusetts

Connecticut

Rhode Island

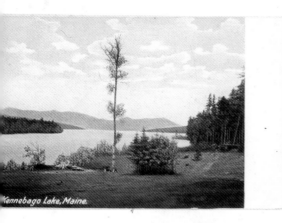

Kennebago Lake, Maine.

→ Maine

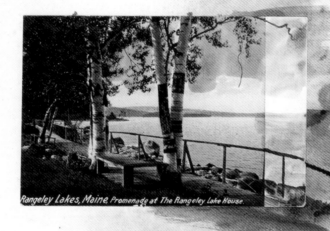

Rangeley Lakes, Maine, Promenade at The Rangeley Lake House.

The old rail
now washed
out.
(1933)

Rangeley

When the author summers

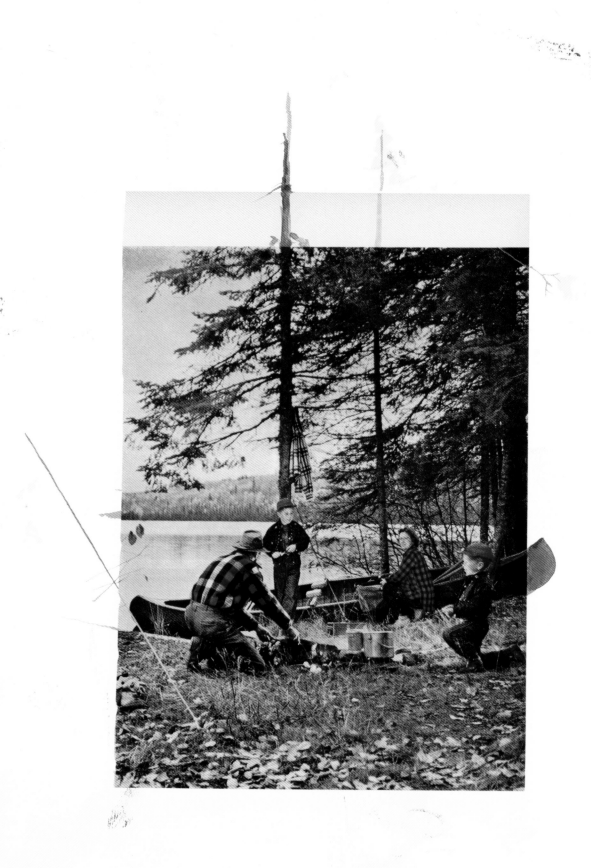

Camp log:

day 3 each day I grow weaker
and closer to god.

day 6 ate bear droppings
 and leaves

day 10 it rained putting
 out my fire.
 only one match left.

day 23 getting weaker

day 25 starting to rain

day 26

day 27

day 28

day 31 found matches
 in waterproof
 container.

 Thank god
 I packed
 them well.

day 32 ate moose
 droppings
 and bark

day 35

Water
or
Juice

dig a
camp disposal
HOLE WITH
ROCKS

PITCH TENT
near water
but high up

Water.

appetizer
 * grapefruit
entree
 * steak
desert
 * ice cream

PTO MAC SLD

5 lbs. ptos. dcd.

1 pkg. clb. mac. or shl. mac.

1 cp. FR. drsg.

4 hd. bld. egs. dcd.

6 tbsp. chpd. grn. ppr.

½ cp. chpd. pmto.

3 cps. thnly. slcd. clry.

¼ cp. mcd. onn.

1 cp. cdr. chse.

ck. ptos. skns
mrnte with FR. drsg.
ad grn ppr pmto, clry.
& onn. ad dsg. of chse.
mx. th. bldd. kp. chld

svs. twlv.

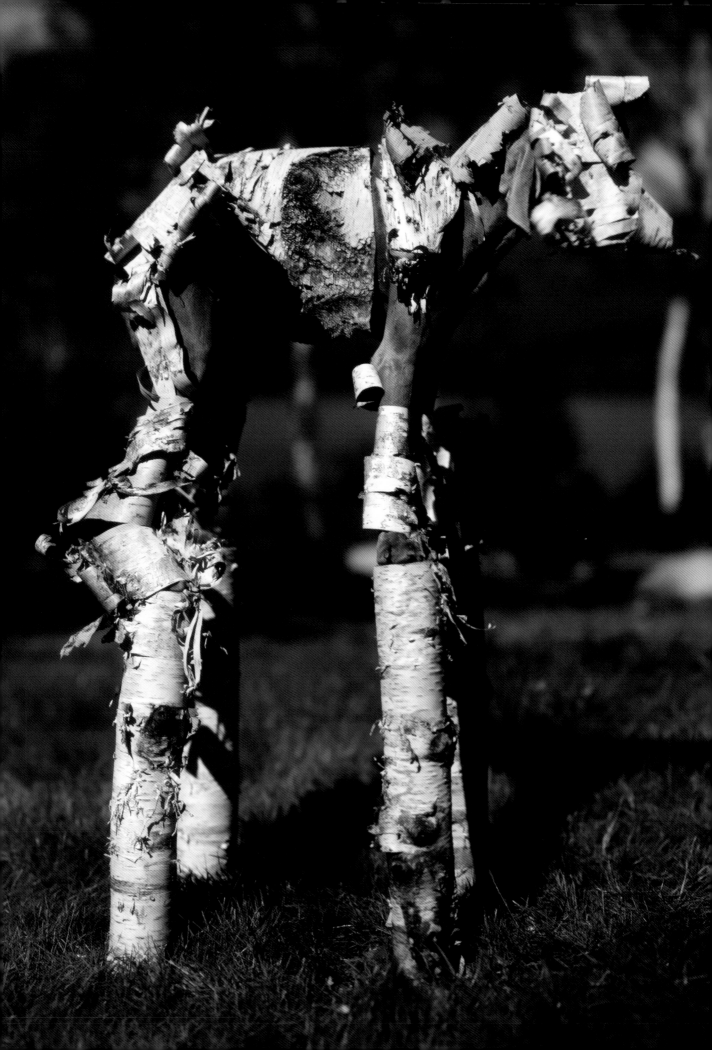

In a walk

In a walk across a narrow field looking up
towards the broad sky at the mountains framed by
the sky and back down the narrow and
up to the sky the mellow boughs
gently swaying in the morning breeze
wild flowers glissening in the clean
crisp air It was during these
moments when I enjoyed lighting up
a cigarette

But with all the negative health reports that
started coming in during the sixties it
became imperative to quit or at
least cut down, first with ligits
and ultra low tar and only after
meals and nervous moments. finally
In 1986 I was able to quit. I can't
say it was easy* but I do feel
better about myself.

* I tried several times before succeeding.

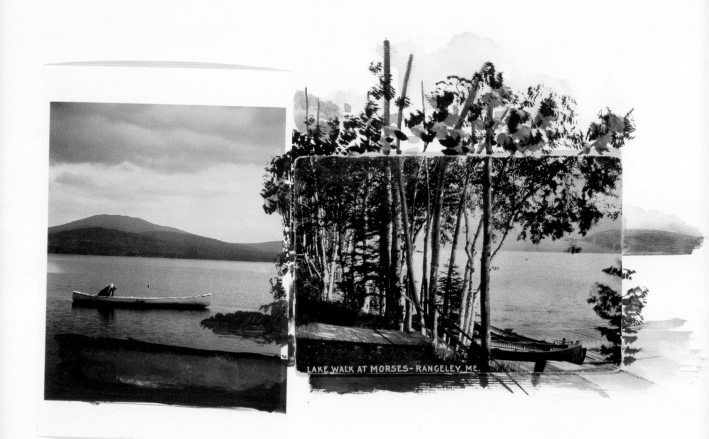

LAKE WALK AT MORSES - RANGELEY, ME.

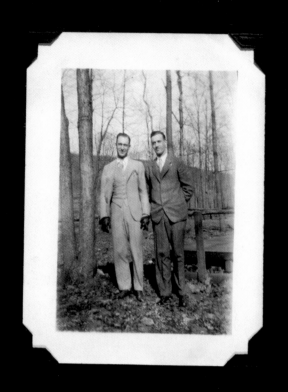

Leave you friends and cabin and go
deep into the woods. go deeper and
deeper into the woods until you come
upon a place that you like.
make a clearing. Stay as long as
you like. Later return to your
cabin. Is your friend still there?
Is he or she still your friend? Is
you cabin just as you left it.
Have you changed? can things
ever be the same?

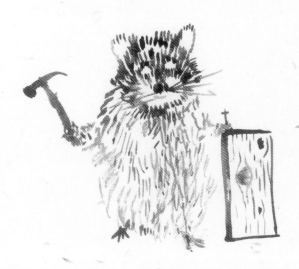

lifs WOOD BEE BOARING WITHOUT ANIMALS AS PETS. WITHOUT PETS LIFE WOOD BEE UNBEARABLE.

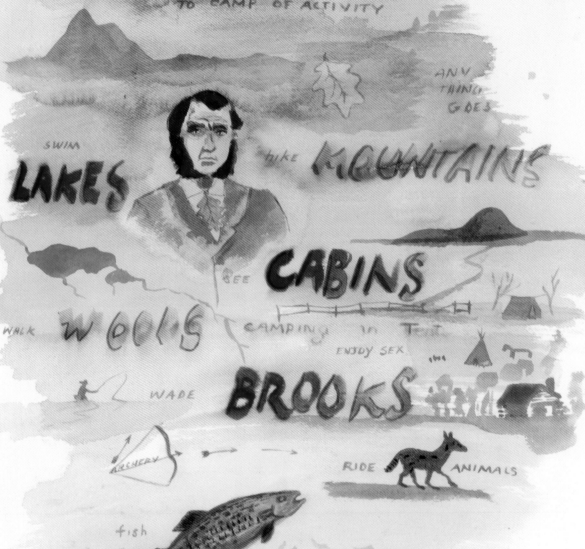

A young buck examines the outermost fringes of camp, then darts away quickly

Wild deer seldom come close to a camp and almost never actually enter a campgrounds. They're leery of all traces of civilization. If you should be lucky enough to have a deer take a quick look — just relax and enjoy the spectacle. The semitame deer sometimes found in parks have lost much of their fear of man so could be considered more dangerous than wild ones. It's best to treat semitame adults with caution. In some western states you might catch a glimpse of an elk or antelope if you keep close watch. In northern canoe country, scan shoreline early in the morning and at dusk for moose.

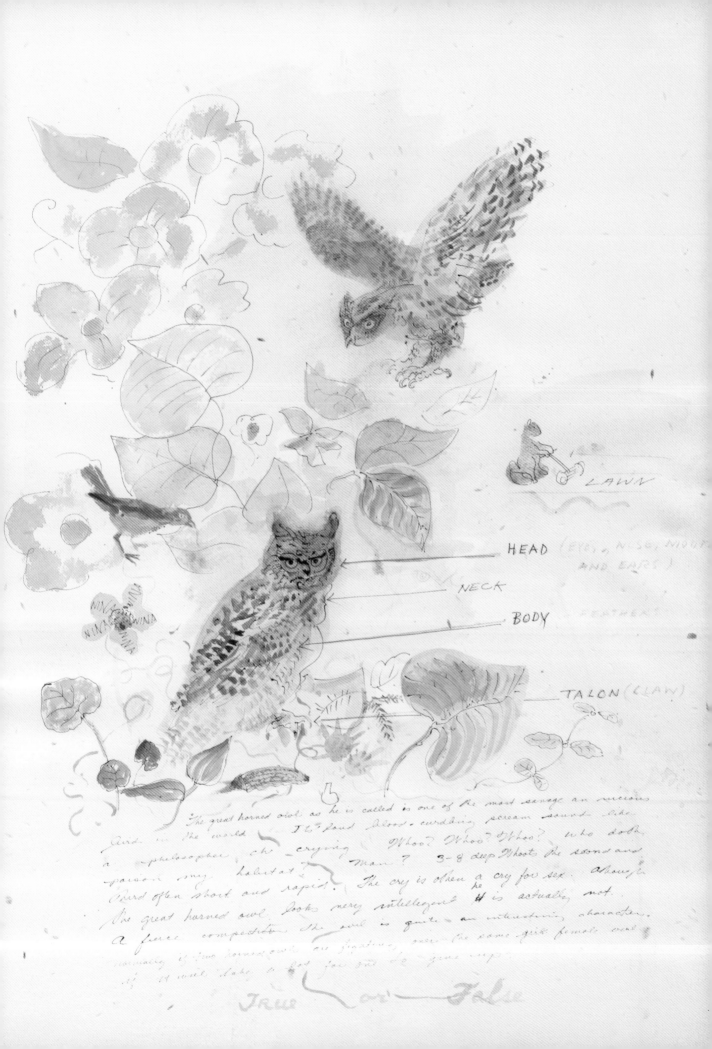

CLAWS

HEAD (EYES, NOSE, MOUTH AND EARS)

NECK

BODY · FEATHERS

TALON (CLAW)

NINJA NINJA NINJA
NINJA NINJA NINJA

The great horned owl as he is called is one of the most savage an vicious
Bird in the world. Its loud blood-curdling scream sounds like
a philosopher oh crying Whoo? Whoo? Whoo? Who doth
poison my habitat? 3-8 deep Whoots the sound and
heard often short and rapid. The cry is often a cry for sex. Although
The great horned owl looks very intelligent he is actually not.
A fierce competitor the owl is quite an interesting character.
Normally if two horned owls are fighting over the same girl female owl
It will take a lot for one to give up.

TRUE or FALSE

CINNAMON TEAL DUCK CAKE

1 ¾ TEAL DUCKS

2 ½ CUPS, CINNAMON

5 CHOPPED NUTS

¾ TSP GARGAN

BAKE UNTIL DONE.
CUT IN SQUARES

serves NINE

ANIMALS hide **IN THE ODDEST PLACES**. YOU HAVE TO
be clever and seek instead IF YOU ARE LOOKING FOR BIRDS
 TO FIND THEM
TRY TO FIND THEIR NESTS. Try to find out
 why birds make nests. Is it so they
can explore secret ways of having bird sex?
 eyes no ears which see rather than hear. Don't drink from
a magnifying glass, use a jar or field glasses.
Don't put eggs in a bag or sack; use
 an egg crate, or specially made box
100% or container for them, then give
 them to animals, but don't
walk quietly **SEASONED** talk and make noise
 so as not to startle their **ENVIRONMENT**
 learn the secrets of your friend so
 they don't become enemies and **ALL**
kill you out their, after you
NATURAL **DIET**
have eaten relax so you
HIGH FIBER ORGANIC **GOODNESS**
don't get an upset stomach but if it
WHOLE keeps happening see
a physician. He will (she will) tell you your food was
gobbled up too fast and as the food passes
your intestines it keeps coiling around until it
passes out. **UNSALTED** nothing **ARTFICIAL**
 MOTHER only kill to eat. **FREE RANGE**

 key words

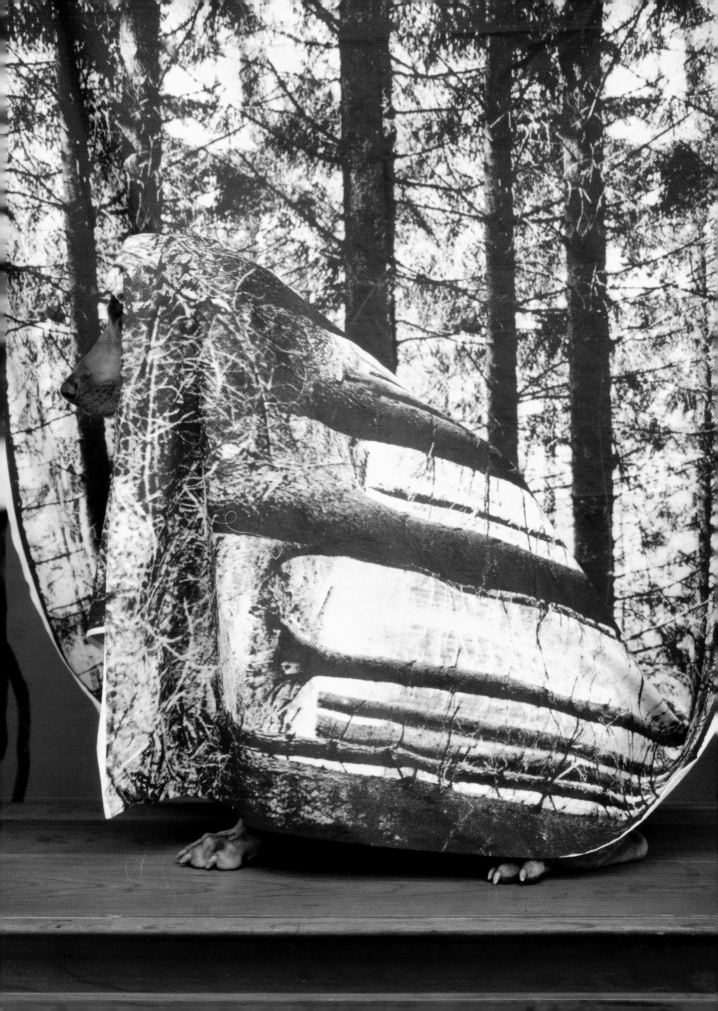

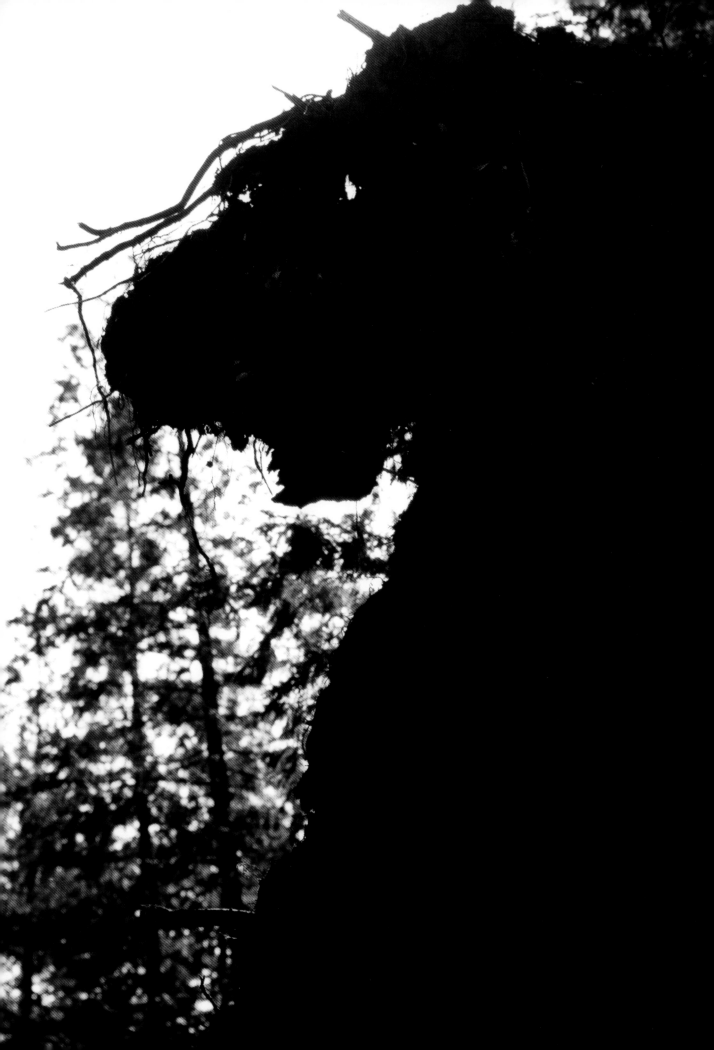

Birds and Animals

Most animals, including the bear, woodchuck, skunk, raccoon, chipmunk, bat and mouse hibernate over the winter. The raccoon will sneak out of the entrance of his or her hollow tree or log or what ever in mild spells in early spring but for the most part stays holed up in a kind of quasi-sleep. Chipmunks of course store plenty of nut and stuff in his underground system of tunnels and dug outs providing himself and his family with much needed food over the long haul. Huddled in her underground domicile, the little squirrel-related mammal eats plenty between extensive and frequent naps, only to appear in the spring rested and ready to begin anew.

Birds too need nourishment over the winter and those that do not remain to endure the cold, migrate to warmer climates, returning in the spring in much the same way year after year after year.

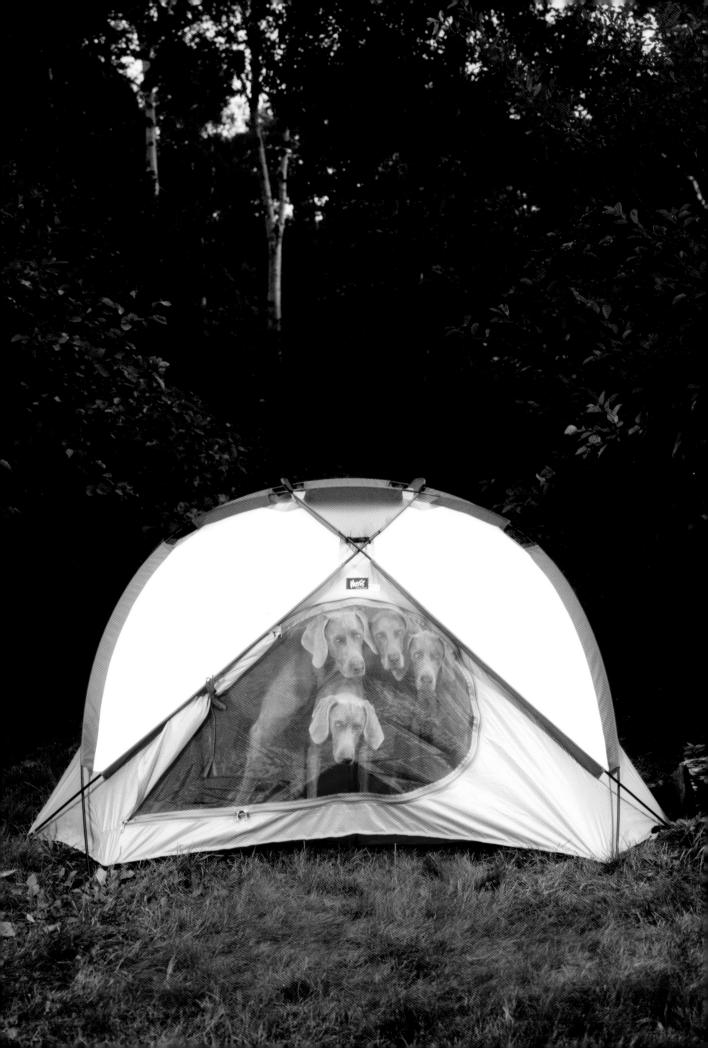

THE MUSHROOMING COST OF
RECREATION IN NORTH AMERICA HAS CAUSED
A WATER SHED OF PROBLEMS TO BOTH CONSUMER
AND PLANNER. WE HAVE GOT TO PREPARE
OUR VACATIONS MORE CAREFULLY, WE HAVE
GOT TO PICK AND CHOOSE FROM AMONG THE
MANY PACKAGES AVAILABLE TO INSURE
THE MOST FROM THE LEAST, IN TODAYS
MARKET THIS IS NOT SO EASY. I DONT
WANT SOUND DOWN. BUT IT IS TOUGH
D A PROBLEM
O
M
S
D
A
Y OU CAN HAVE AN INT
 E
 R
 E
 S
 T IME
 I
 N
 GOING CAMP
 I
 N
 JUST DONT STAY FOR LONG

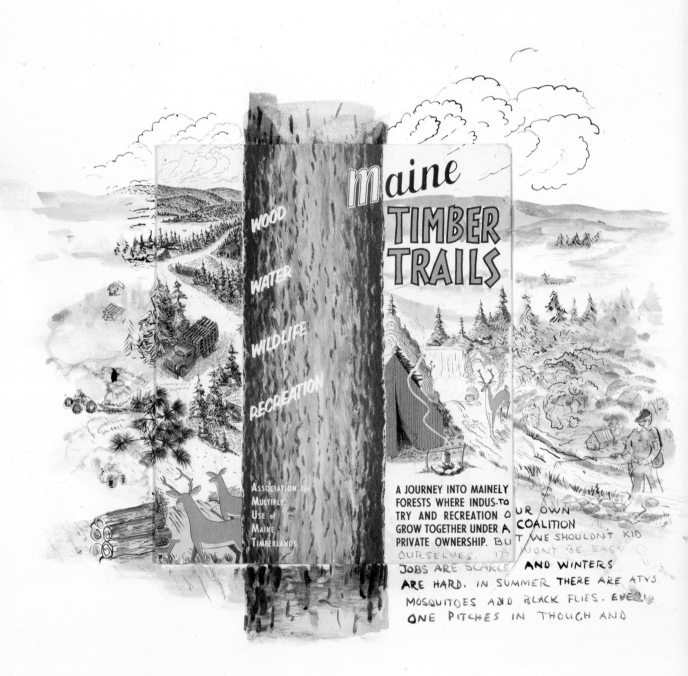

Maine

TIMBER
TRAILS

WOOD

WATER

WILDLIFE

RECREATION

ASSOCIATION for
MULTIPLE
USE of
MAINE
TIMBERLANDS

A JOURNEY INTO MAINELY
FORESTS WHERE INDUS-TO
TRY AND RECREATION O UR OWN
GROW TOGETHER UNDER A COALITION
PRIVATE OWNERSHIP. BU T WE SHOULDN'T KID
OURSELVES. IT WONT BE EASY.
JOBS ARE SCARCE AND WINTERS
ARE HARD. IN SUMMER THERE ARE ATVS,
MOSQUITOES AND BLACK FLIES. EVERY
ONE PITCHES IN THOUGH AND

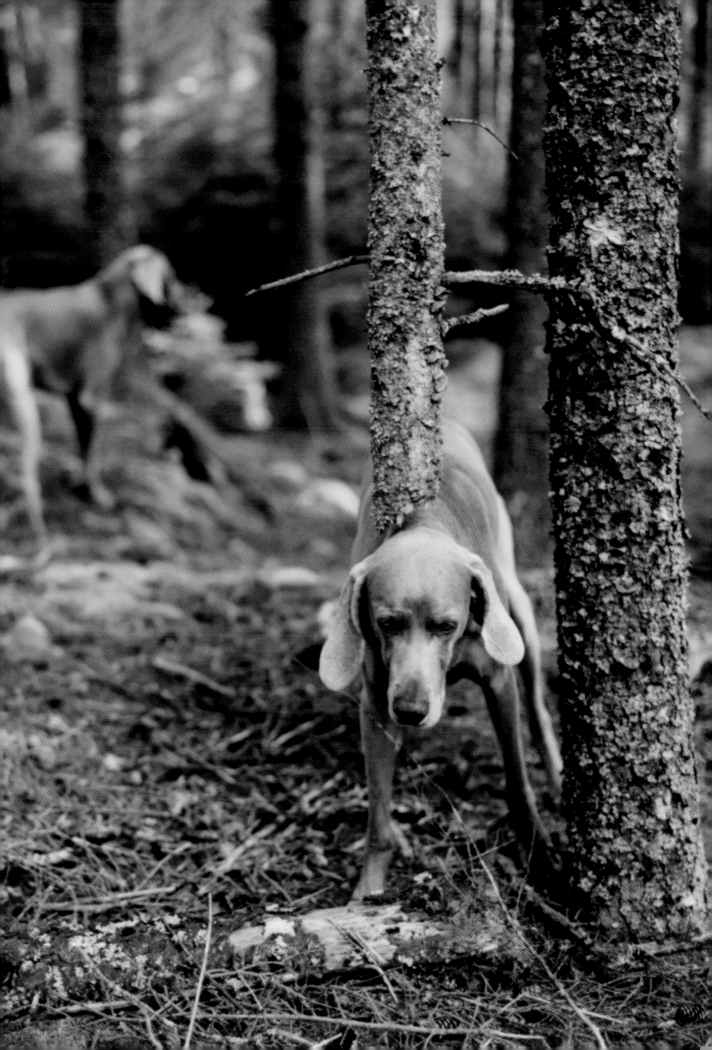

Worm

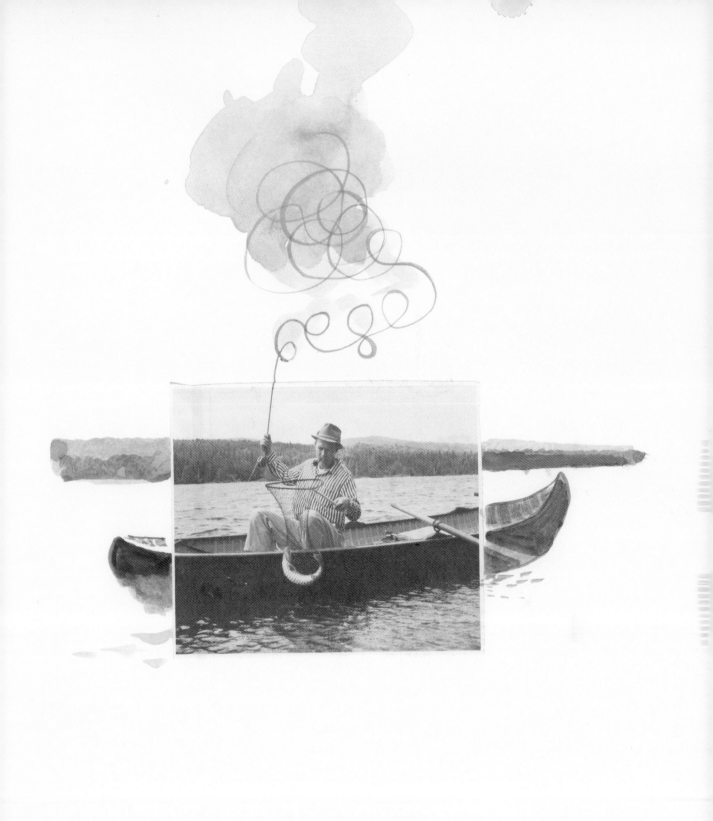

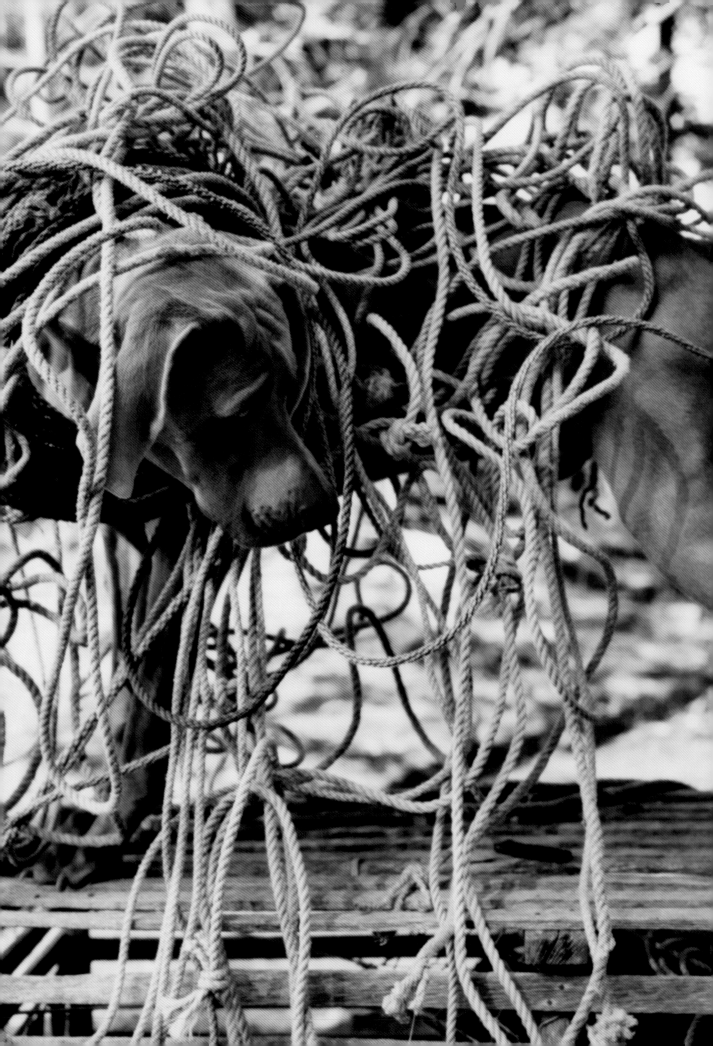

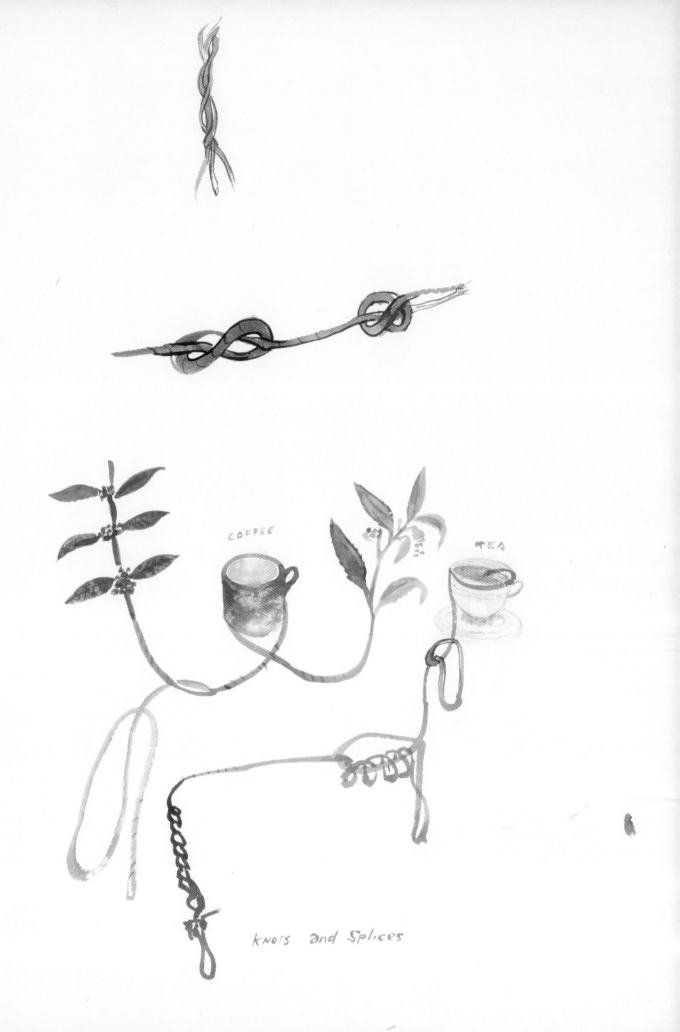

COFFEE

TEA

Knots and Splices

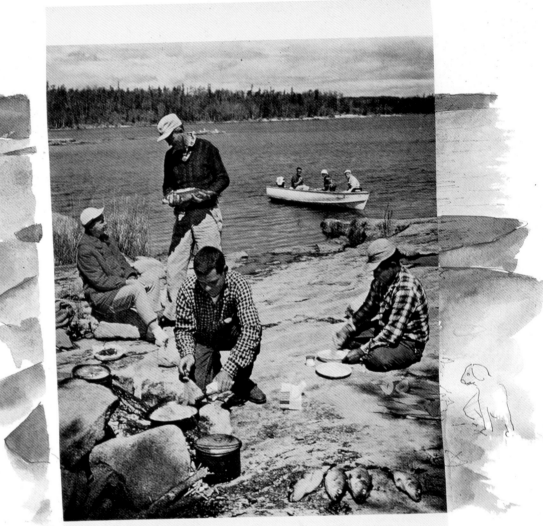

This rocky shore offers a natural stone "fireplace" that's ideal for fish-fries

Lucky fishermen pull up to shore and treat themselves to crisp-fried fish at midday. The fixin's stay simple—a few cooking utensils, some cornmeal, shortening, and a good bed of fire coals do the job. These campers singled out the three big stones that furnished a natural pocket for fire. Usually, you can count on gathering enough wood for one fire without having to chop or split logs.

OPEN PIT DINNER

1 6 lb ROUND STEAK

1 VANILLA WAFER

1 CUP CHOPPED PARSLEY

1 EGG BEATEN AND FRIED

4 CUPS THINLY SLICED CELERY

4 MEDIUM TOMATOES MASHED

4 SQUARES UNSWEETED CHOCOLATE

4 CUPS EVAPORATED MILK

Serves **8** ADULTS
TWENTY THINGS

PLUS 28
ADD 16
TOTAL √44

9

5

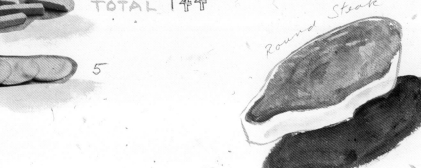

Round Steak

celery

8

Time is both eternal and
ephemeral. The mayflies for
but a day yet the days are
filled with the flies of May.
When one looks at a
single snowflake through the
magnifying glass of the
microscope one sees a
geometric pattern of crystaline
beauty and perfection
yet it melts

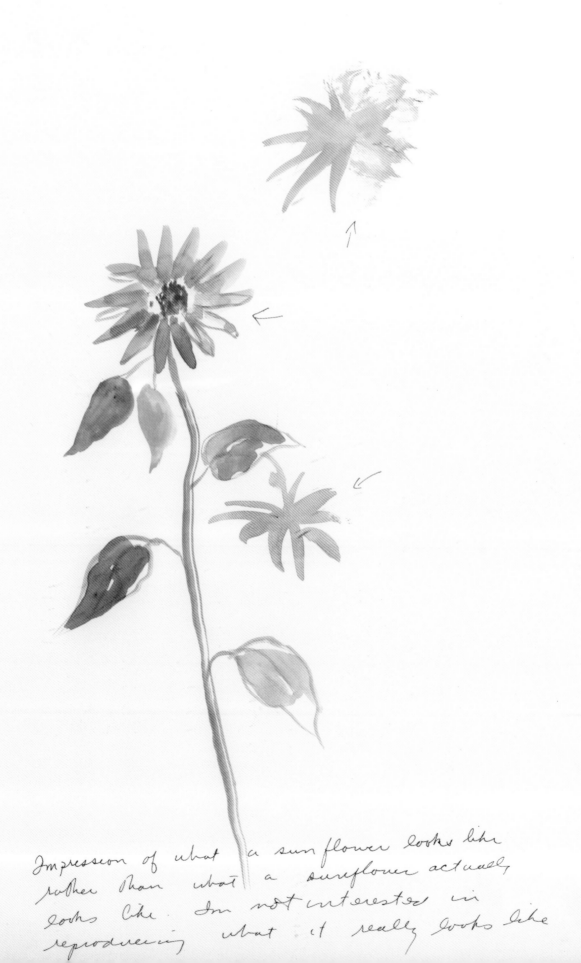

Impression of what a sunflower looks like
rather than what a sunflower actually
looks like. I'm not interested in
reproducing what it really looks like

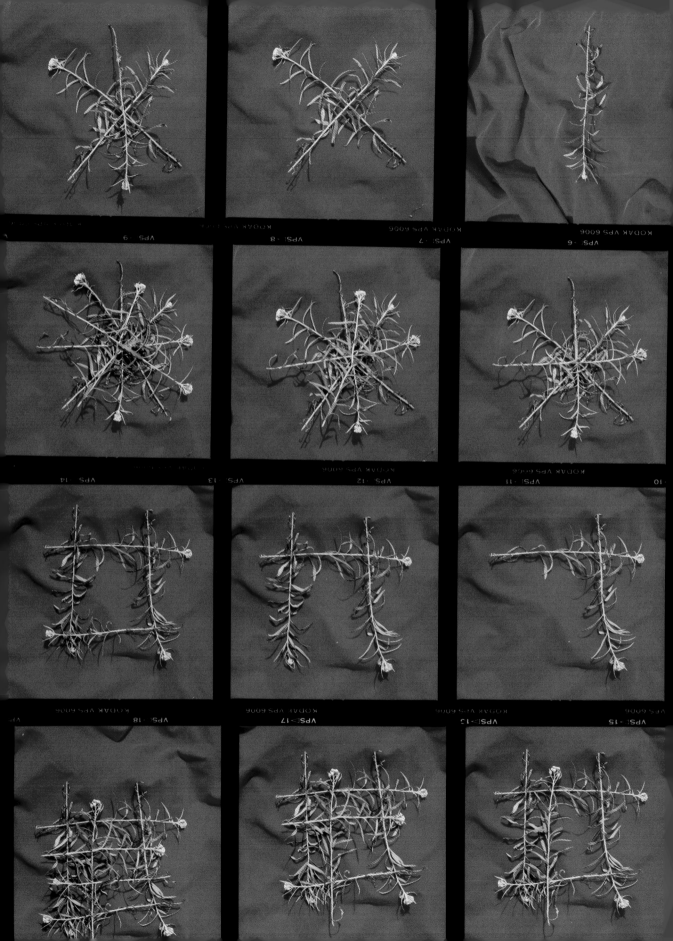

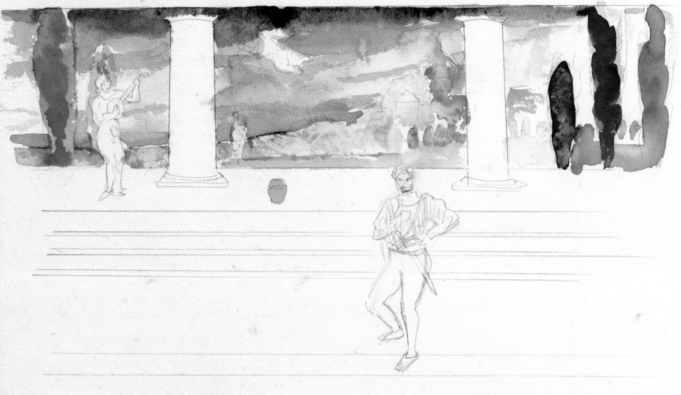

The garden The flower

The flower of civilization

The flower of civilization is of course man
and woman — MEN and WOMEN or WOMEN AND
MEN and the garden. The degree to which
CIVILIZATION FLOWERS depends upon the quality
of their union and the fruit it PRODUCES.
Also the relationship of men to men, and
women to women, woman to woman, man
to man, men to woman and women
to man.

There is only one true path

There are two true paths

The path taken by me

The path chosen by you

The one by me
which is true?

The one by you
which is true?

here

There is only one true path

ME

YOU

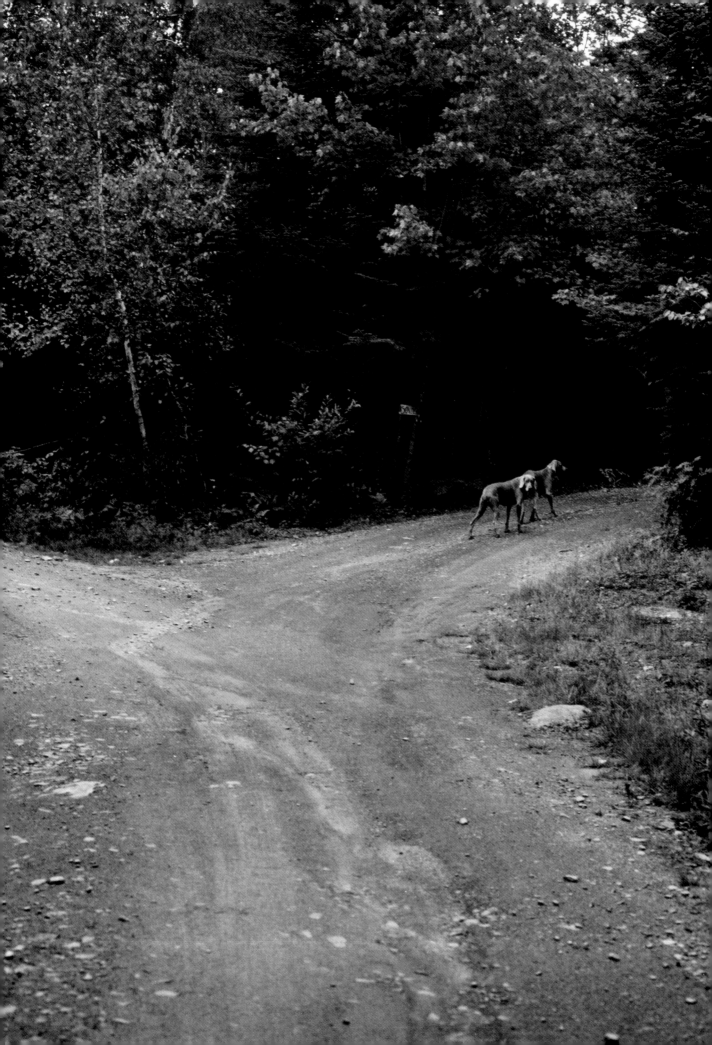

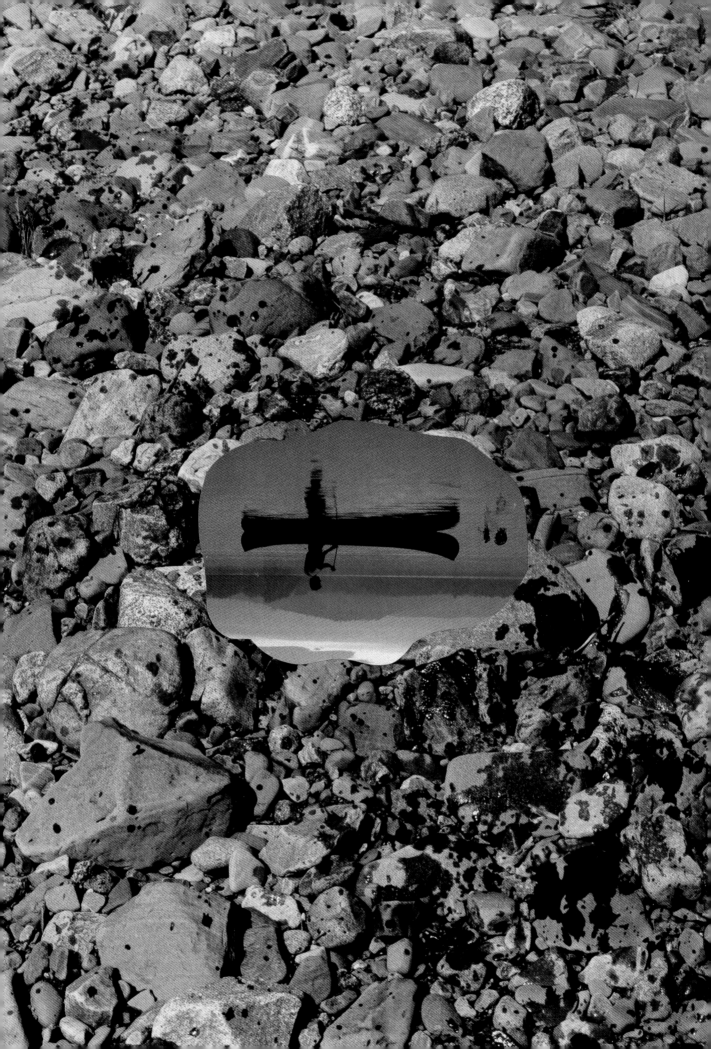

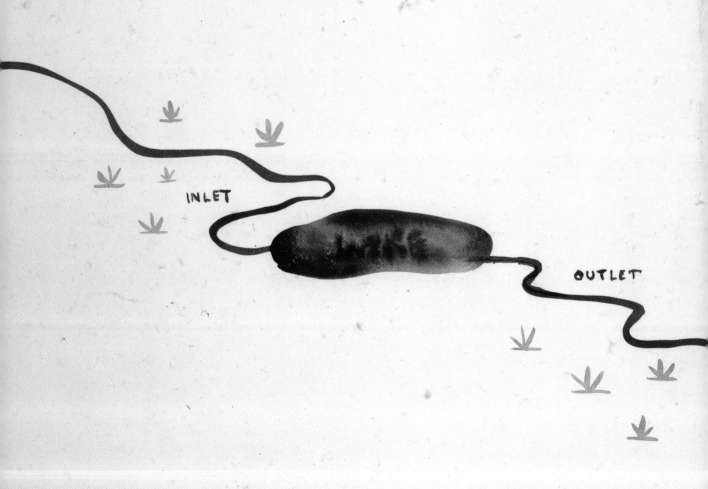

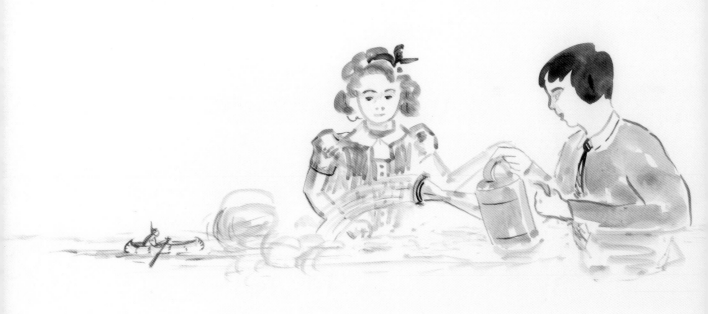

Don't Forget Your Childhood

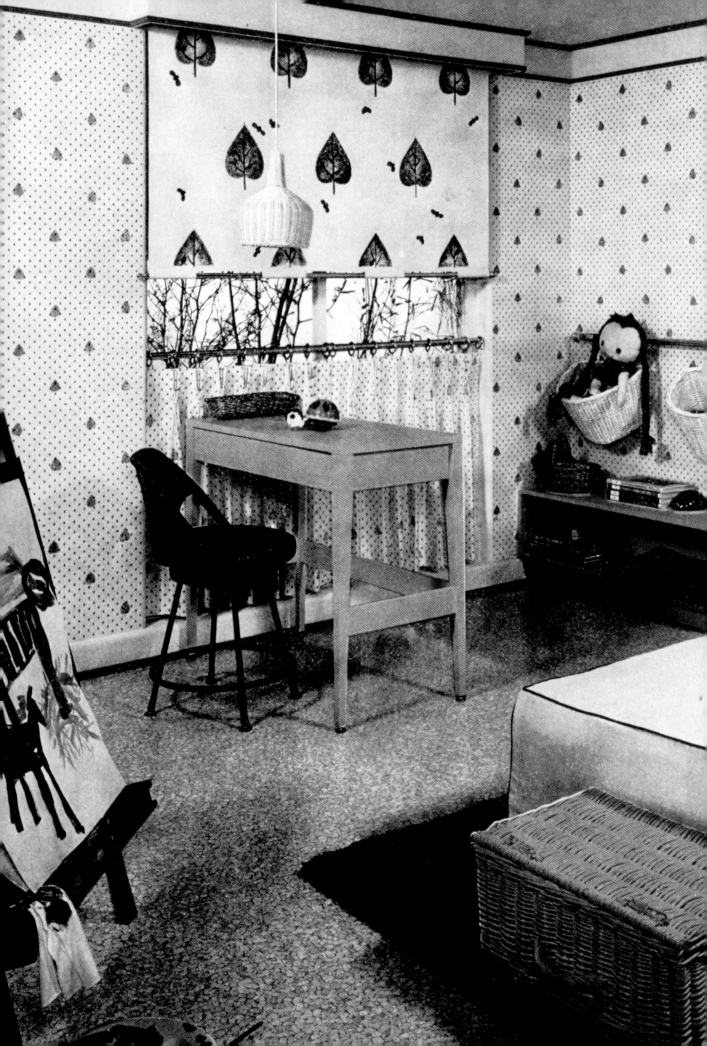

A MAP OF YOUR ROOM

You can draw a picture of your room two different ways.
One way is
to sit in your room
and draw whatever you see.

The other is to pretend
that you are looking down
through a hole
in the ceiling.

Ever so nimble, William Wegman is in both places at once. At the same time that he situates himself within a space, studying it at arm's length, he peers down from that hole in the ceiling, as though through a child's periscope, surveying the scene and spying himself in the very act of drawing. He is both within and without, never losing sight of (or masking) the theatricality of artistic creation.

Why

IS THE SKY BLUE?

Art making, for Wegman, is predicated on this self-conscious dualism. He has described his itinerant artistic practice (working in video, photography, painting, drawing) as "tourism" of a sort: "The best way to visit is to blend in. After wandering around in the place for a while, I come to some sort of conclusion. It's often in counterpoint to the source."[1] Often described as "chameleon-like," Wegman can burrow into various media while exploiting the detachment that transcience affords him. "Blending in," a strategy of the conceptual artist and child adventurer alike, is certainly central to Wegman's creative process, but it is also thematized throughout his work. Among his photographic pre-occupations are images in which camouflage—his Weimaraners on a rocky beach, for example—is punctured by recognition.

Nineteenth-century American transcendentalist Henry David Thoreau, whose thinking often bubbles to the surface in Wegman's work, especially his prose, would have approved of the artist's gambit. Thoreau famously privileged the estranged perspective of the traveler, even advocating the virtues of posing as a foreigner in one's own community: "When you are starting away—leaving your more familiar fields for a little adventure like a walk—you look at every object with a travellers or at least with historical eyes—you pause on the first bridge.— where an ordinary walk hardly commences, & begin to observe & moralize like a traveller— It is worthe the while to see your native Village thus sometimes—as if you were a traveller passing through it—commenting on your neighbors as strangers."[2]

WHY DO STARS TWINKLE?

Under the metaphoric sign of a tourist or traveler, then, Wegman has ventured into the preserve of the American landscape tradition again and again over the course of his career. His passage is perhaps most literally recorded in one of his photographic interventions. On the surface of an original—but flawed—print by nineteenth-century American photographer Carleton Watkins, Wegman adds text calling out both the falls and the creator (pp. 42–43). He invites us to consider this a transgression. And yet what is most striking about this action is its benign redundancy: Wegman tells us nothing untrue, and nothing that we do not already know. The very obviousness of his gesture renders it almost inscrutable.

HAIL OR SLEET

Watkins's photograph belongs to a series of images of the Yosemite Valley that ultimately generated a groundswell of support for the area's preservation. These photographs, which satisfied painterly expressions of sublimity, came to participate in narratives about the purity of landscape subjects and the transparency of the photographic medium. Wegman's action slyly reappropriates the photograph as a surface and, by implication, exposes it as a representation. "Photo by Watkins" is scrawled across the surface of the river in the lilting style of a midcentury studio photographer's stamp. Wegman asserts the photographer's authorship even as he displaces him, coloring access to his image. While its stillness is a consequence of technological limitations, the placid body of water in the foreground is the most spiritually resonant passage in the photograph, imbuing it with a certain existence outside of time. It is here, critically, that Wegman interjects his temporality.

With this photograph, Wegman acknowledges in his characteristically sidelong way that the Watkins belongs to a family of images on which he will lean. He will borrow from the conventions of landscape, but elastically, only insofar as he can recast them and expose the fallacies underlying these representations. Indeed, an earlier painting after another photograph by Watkins seems to acknowledge this debt as it radiates with an apparitional quality. Wegman depicted the frothy waterfall emerging from a thicket of scumbled brushwork with no descriptive pretensions. It is familiar and yet distant, a fragment of a remembered vista.

COULD YOU DIG A HOLE THROUGH THE WORLD?

This relationship to a genealogy of landscape is made even more explicit in a series of paintings and drawings rooted in found postcards. Wegman uses these vernacular images as the basis for compositions, affixing them to a sheet of paper or a canvas and extrapolating from them. Often, Wegman floats a single card in the center of the page, using watercolor to extend stray tendrils of the image. His delicate handling of the pigment cannot help but impress. Some of the postcards are more elaborately embedded, doubling as a canvas on a wall or window, the punning elision between a roll of carpet and a stretch of beach.

In many instances the postcards appear as something other than *objets d'art* or windows, historically the metaphoric standard for illusionistic painting. Instead, Wegman allows the postcards to retain their status as both cultural artifacts and sites, stitching them together and transitioning between their eclectic, often kitschy imagery. The result is a delirious topography into which the physical cards themselves dissolve. Even as these tableaux flout artistic convention in their irrational spatiality, they rely on mainstays of pictorial organization, using bounding roads to guide the eye and foreground elements to imply receding space, for example. Some of these paintings are so dense that they almost buckle, thoroughly scattering your attention and undermining the very currency of the postcard as a fixed coordinate in space and time and also a personal missive. Even so, the tone of these works is more puckish than mocking.[3]

THE DEEPEST HOLE IN THE EARTH
WOULD NOT BE DEEP ENOUGH
TO SHOW ON A MAP OF THE WORLD
THIS SIZE.

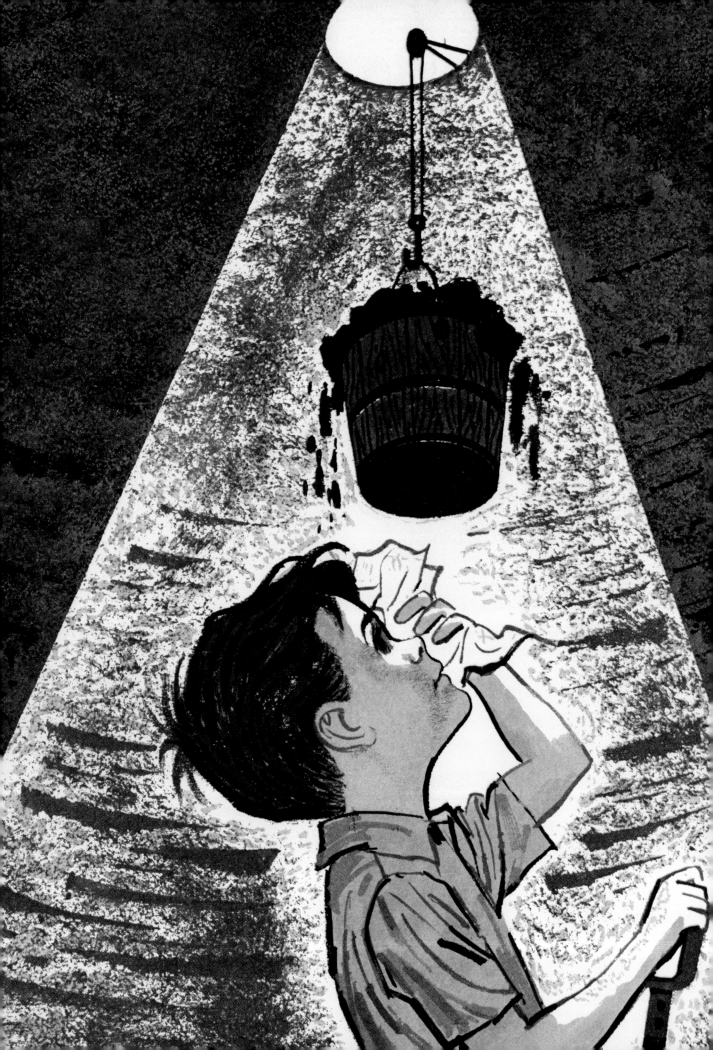

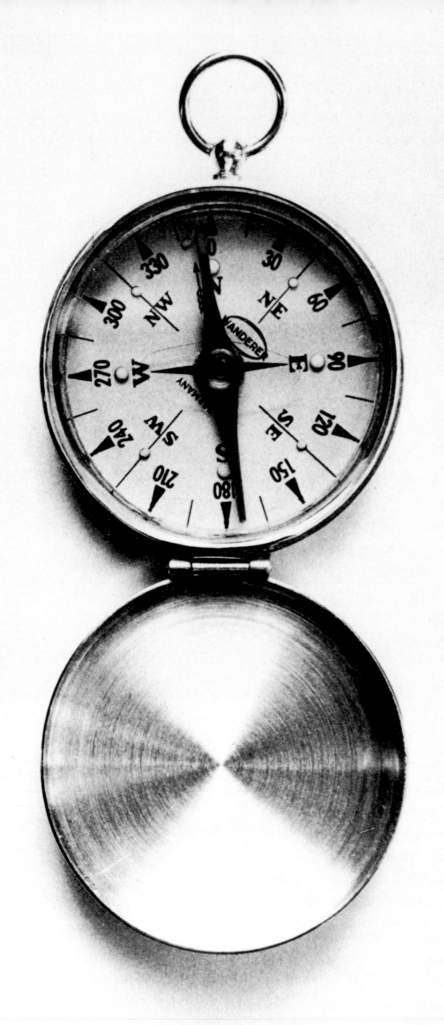

MAKE YOUR OWN COMPASS

Based as they are on existing visualizations of "real" places, the postcard paintings are hybridized spaces. In this they are consistent with Wegman's images of a dog draped in a photographic print of trees or encircled with birch bark, attempts to literally merge figure with setting. If Wegman consistently draws attention to the inauthenticities of his own operations, he does so for good reason. He reminds us that any image is necessarily narcissistic, fixated on its own making, and that, historically, landscape is no less a fictionalized projection than any other painterly genre.

With his postcard paintings especially, Wegman pries representation from reality, reinvigorating both. Taking nothing for granted, in the spirit of Thoreau's traveler, he seems to ask his artist antecedents the very question that he first encountered in a children's book: "Why must the sky be blue?" The answer, Wegman tells us, is that it isn't, and it mustn't. He forces us to appreciate the mechanics of art making for what they are and, ultimately, he drives us back into nature. "Leave your friends and cabin," Wegman urges in one of his drawings, "and go deep into the woods."

—Diana Tuite,
Mellon Curatorial Fellow,
Bowdoin College Museum of Art

Notes

1. Quoted in "Pencil and Paper—Interview," in Frédéric Paul, *William Wegman Dessins/Drawings: 1973–1997* (Limoges: Fonds regional d'art contemporain du Limousin, 1997), p. 100.

2. Henry David Thoreau, *A Year in Thoreau's Journal: 1851*, introduction by H. Daniel Peck (New York: Penguin Books, 1993), p. 194.

3. Donald Kuspit, for one, has written of Wegman's paintings: "Indeed, his landscape paintings are a kind of pictorial nonsense; they mock the idea of the majestic landscape—the spatial landscape for rendering sublime space—in the very act of showing great mastery of it and, one might say, a certain longing for it and what it embodies." Kuspit, "The Mock Majestic: William Wegman's Landscape Paintings," in *The History of Travel: The Catalogue of An Exhibition of Paintings by William Wegman* (Cincinnati: Taft Museum; Youngstown: Butler Institute of American Art, 1990), p. 4.

Works in the Exhibition

All works collection of the artist unless otherwise noted.

Untitled (leaves on/leaves off), 1969
Silver gelatin print
Two panels, 4¾ x 3¾ inches each

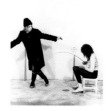 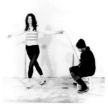

Illegal Fishing/Illegal Skating, 1971
Silver gelatin print
Two panels, 11 x 10¾ inches each

Illusion, 1972
Pencil on paper
8½ x 11 inches

Lady Luck, 1973
Pencil on paper
8½ x 11 inches

Landscape Color Chart, 1973
Pencil on paper
8½ x 11 inches

Flashlight, 1974
Ink and watercolor on paper
11 x 8½ inches

Dangerous/Safer, 1974
Pencil on paper
11 x 14 inches

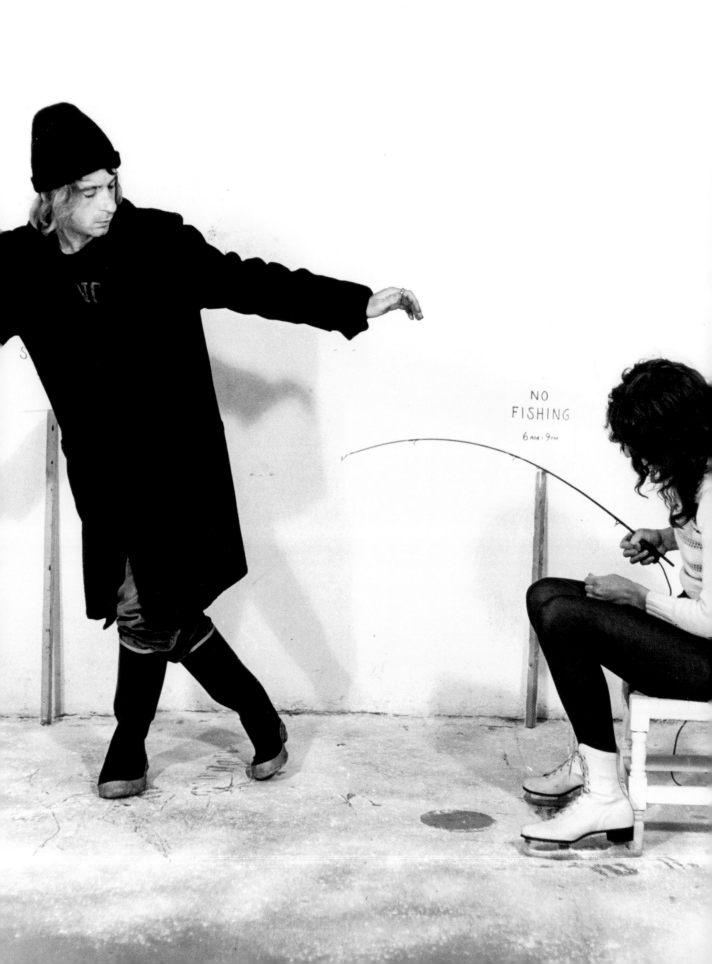

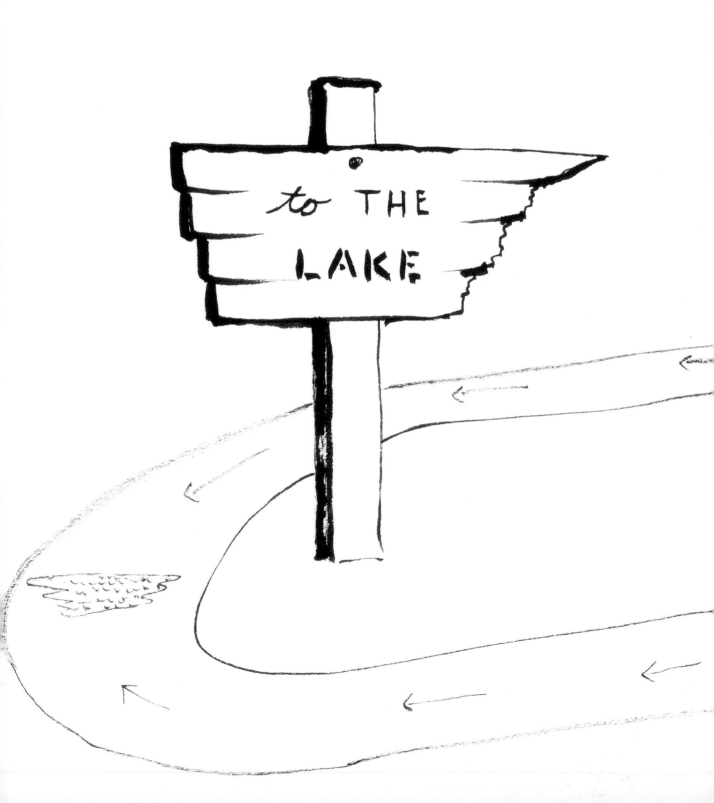

Frustrating Board, 1974
Pencil on paper
8½ x 11 inches

Oyster Opened, 1975
Ink on paper
8½ x 11 inches

Plants and Animals, 1976
Watercolor on paper
11 x 8 inches

Boat/Bow, 1978
Pencil and watercolor on paper
8½ x 11 inches

To the Lake, 1984
Ink on paper
7 x 7 inches

School in 1950, 1984
Ink on paper
11 x 14 inches

Catch Anything?, 1985
Ink and pencil on paper
8½ x 11 inches

Where's Dean?, 1985
Watercolor on paper
11 x 14 inches

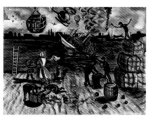

Dock Scene, 1985
Oil and acrylic on canvas
14 x 19 inches

Hope, 1985
Oil on canvas
20¼ x 25¼ inches

What is Sound?, 1985
Oil on canvas
15¼ x 12¼ inches

Birch Bay, 1985
Oil on canvas with birch bark
18 x 23 inches

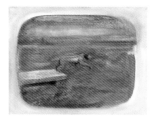

Dock, 1986
Oil on canvas
12 x 16 inches

Untitled (Fay contact sheet), 1988
Chromogenic print
39 x 30 inches

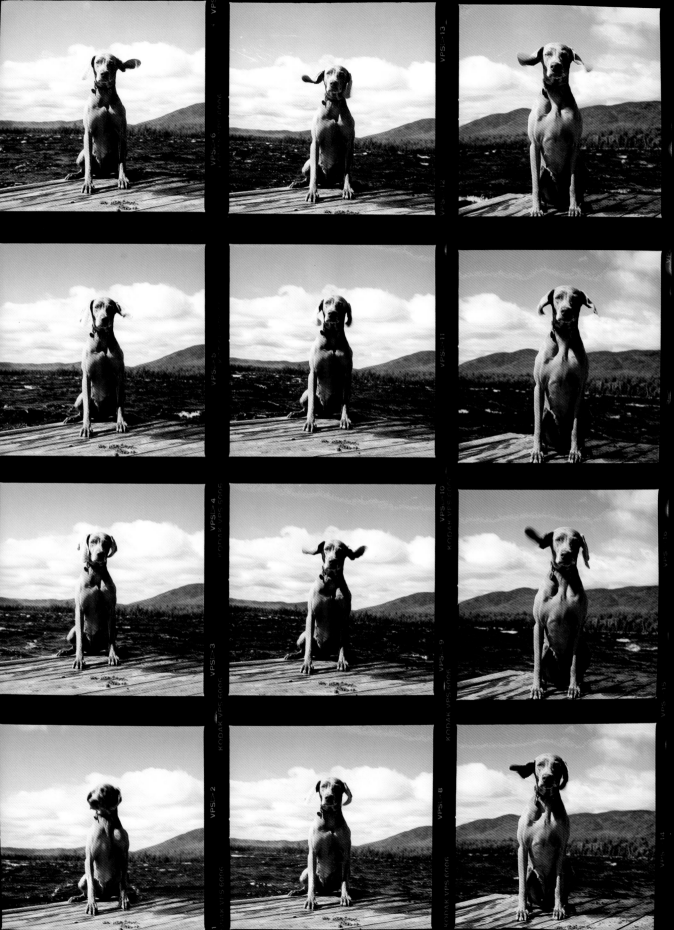

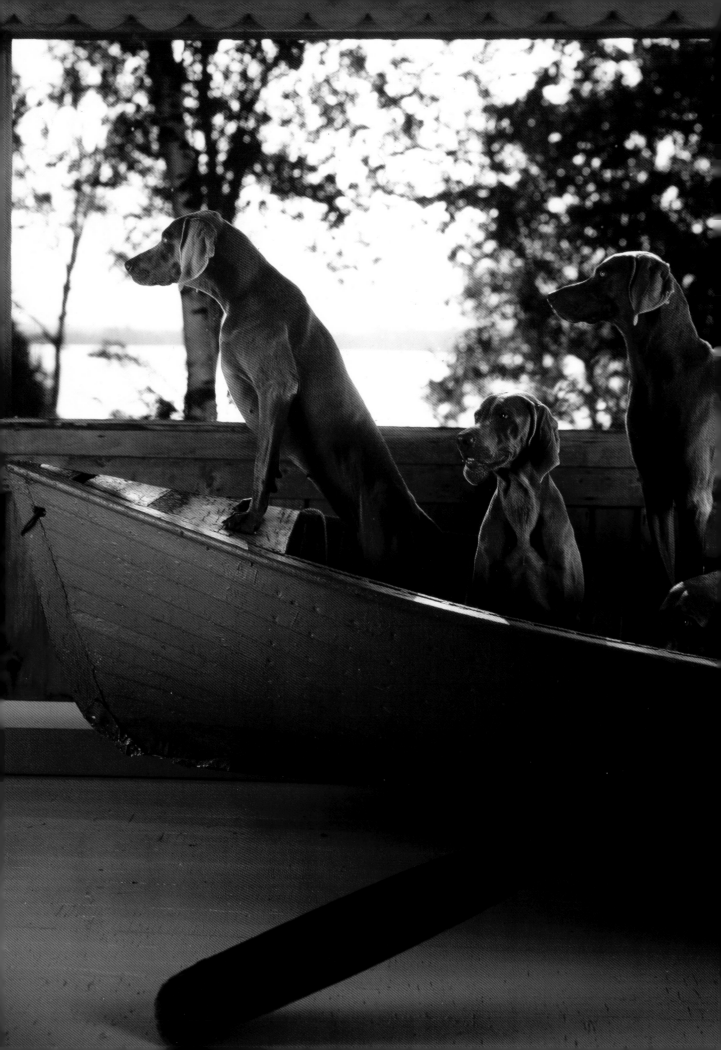

Activities 1, 1989
Watercolor on paper
30¼ x 22¼ inches

Arch de Birch, 1990
Color Polaroid
24 x 20 inches

Night Rider, 1990
Color Polaroid
24 x 20 inches

Don't Forget Your Childhood, 1991
Ink on paper
11 x 14 inches

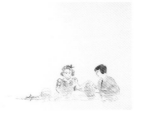

Dogs Imitating Rabbits, 1991
Watercolor on paper
9 x 12 inches

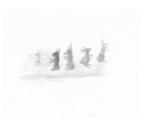

Duck Fishing, 1991
Watercolor on paper
10 x 12 inches

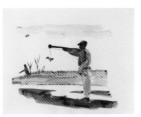

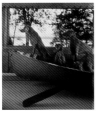 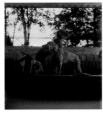 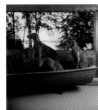

Crossing, 1991
Color Polaroid
Three panels, 24 x 20 inches each

Over Look, 1991
Color Polaroid
24 x 20 inches

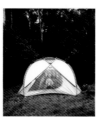

Shelter, 1991
Color Polaroid
24 x 20 inches

Wood Work, 1991
Color Polaroid
24 x 20 inches

Camofleur, 1992
Color Polaroid
24 x 20 inches

Moose Crossing, 1992
Color Polaroid
Two panels, 24 x 20 inches each

Activities, 1992
Oil and acrylic on canvas
58 x 60 inches

Duck Impression, 1992
Watercolor on paper
14 x 11 inches

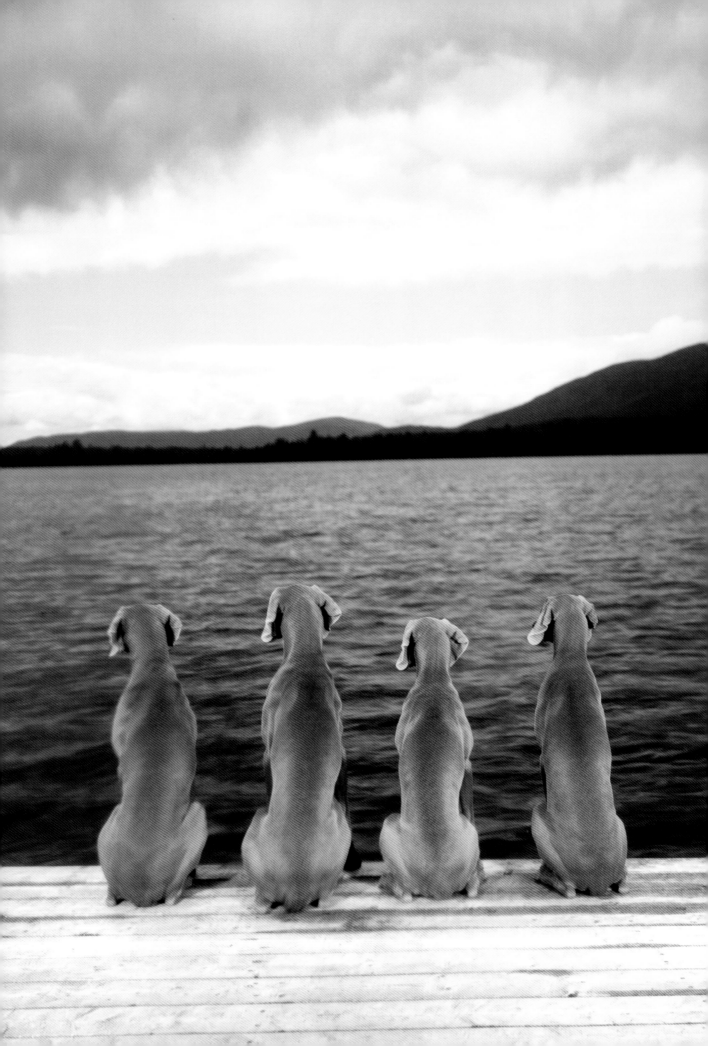

House Wish, 1992
Watercolor on paper
14 x 11 inches

Nothing Later, 1992
Watercolor on paper
14 x 11 inches

Sunflower Impression, 1992
Watercolor on paper
14 x 11 inches

Fishing the Boundary Waters, 1993
Gouache and postcard on paper
16 x 20 inches

Pto Mac Sld, 1993
Watercolor and birch bark on paper
20 x 16 inches

Old Boys and Young Girls, 1993
Watercolor on paper
20 x 16 inches

*Life Wood Bee Boaring Without Animals
 as Pets*, 1993
Watercolor on grass seed paper
20 x 16 inches

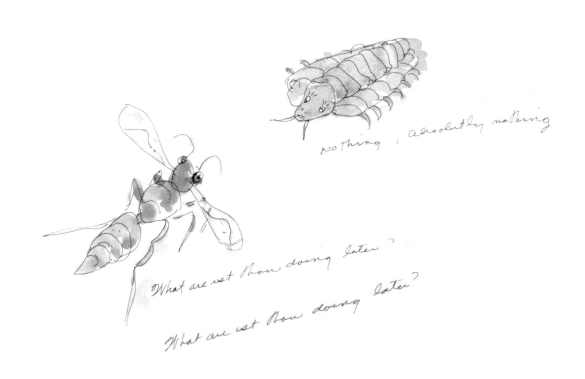

nothing, absolutly nothing

What are ist thou doing later?

What are ist thou doing later?

Field Guide to North America and to Other Regions (selections), 1993
Unique books in boxes
Panels measuring 20 x 16 inches each

Watkins, 1993
Oil and acrylic on canvas
52 x 62 inches

Untitled contact sheet, 1993
Chromogenic print
20 x 16 inches

Untitled contact sheet, 1993
Chromogenic print
20 x 16 inches

Untitled contact sheet, 1993
Chromogenic print
20 x 16 inches

Untitled contact sheet, 1993
Chromogenic print
20 x 16 inches

Untitled contact sheet, 1993
Chromogenic print
20 x 16 inches

Untitled contact sheet, 1993
Chromogenic print
20 x 16 inches

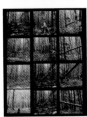

Untitled contact sheet, 1993
Chromogenic print
20 x 16 inches

Untitled contact sheet, 1993
Chromogenic print
20 x 16 inches

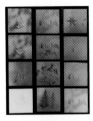

Untitled contact sheet, 1993
Chromogenic print
20 x 16 inches

Untitled contact sheet, 1993
Chromogenic print
20 x 16 inches

Untitled contact sheet, 1993
Chromogenic print
20 x 16 inches

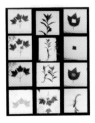

Untitled contact sheet, 1993
Chromogenic print
20 x 16 inches

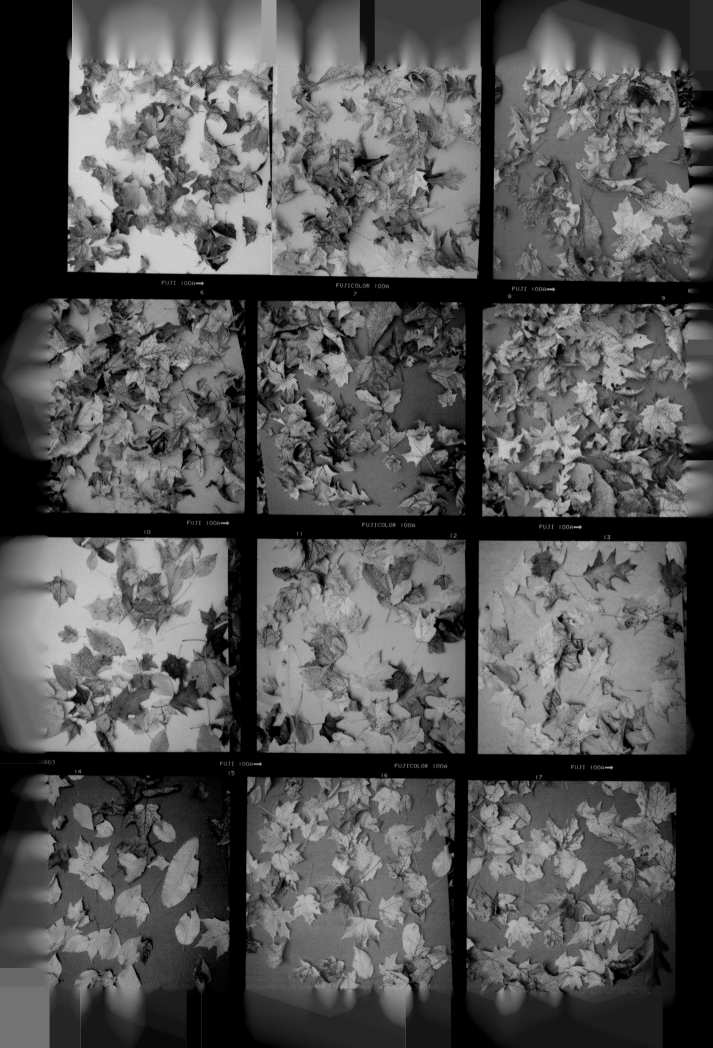

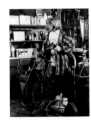

The Hardly Boys: Driller Bill, 1993
Black-and-white Polaroid
4¼ x 3¼ inches

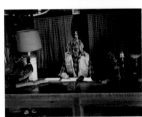

The Hardly Boys: Mr. Hardly, 1993
Black-and-white Polaroid
3¼ x 4¼ inches

*The Hardly Boys: The Case of the Missing
Caretaker*, 1993
Black-and-white Polaroid
4¼ x 3¼ inches

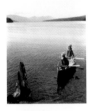

The Hardly Boys: Mystery Island, 1993
Black-and-white Polaroid
4¼ x 3¼ inches

The Hardly Boys: The Lady in Pink, 1993
Black-and-white Polaroid
4¼ x 3¼ inches

The Hardly Boys: Undisclosed Location, 1993
Black-and-white Polaroid
4¼ x 3¼ inches

The Hardly Boys: The Missing Guest, 1993
Color Polaroid
24 x 20 inches

The Hardly Boys: Bucket Loaded, 1993
Color Polaroid
24 x 20 inches

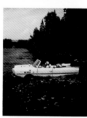

The Hardly Boys: Rescue, 1993
Color Polaroid
24 x 20 inches

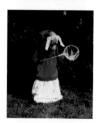

The Hardly Boys: Netter, 1994
Color Polaroid
24 x 20 inches

The Hardly Boys: The Missing Story, 1994
Color Polaroid
24 x 20 inches

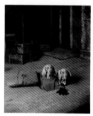

The Hardly Boys: The Second Story, 1994
Color Polaroid
24 x 20 inches

The Hardly Boys: Up To No Good, 1994
Color Polaroid
24 x 20 inches

The Hardly Boys: Vacation Land, 1994
Color Polaroid
24 x 20 inches

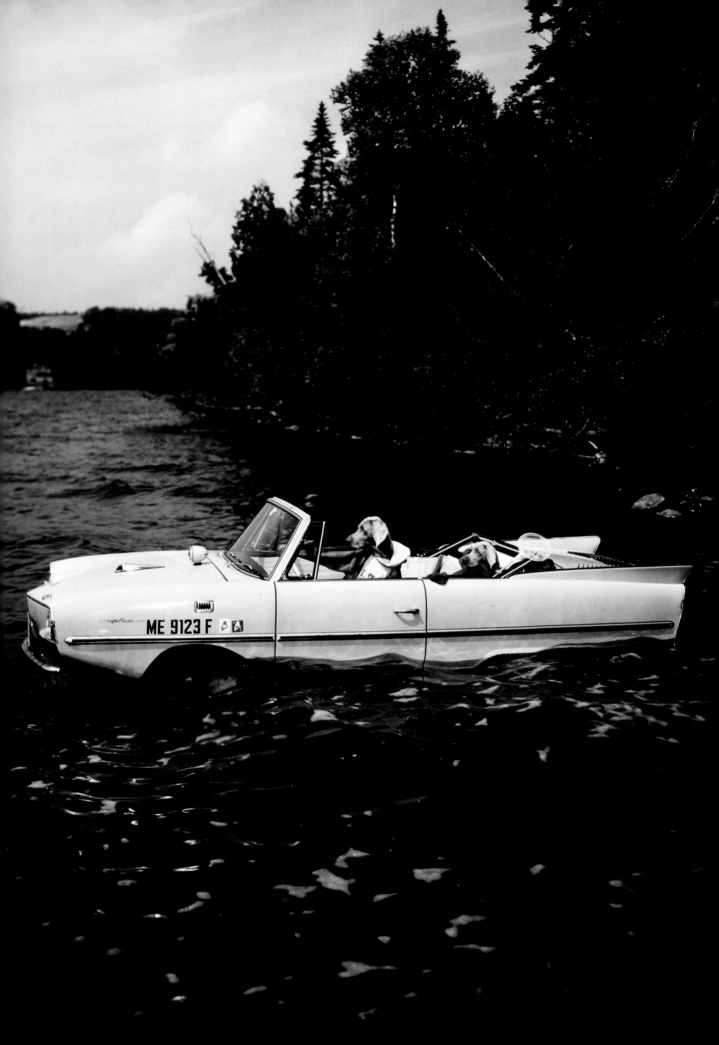

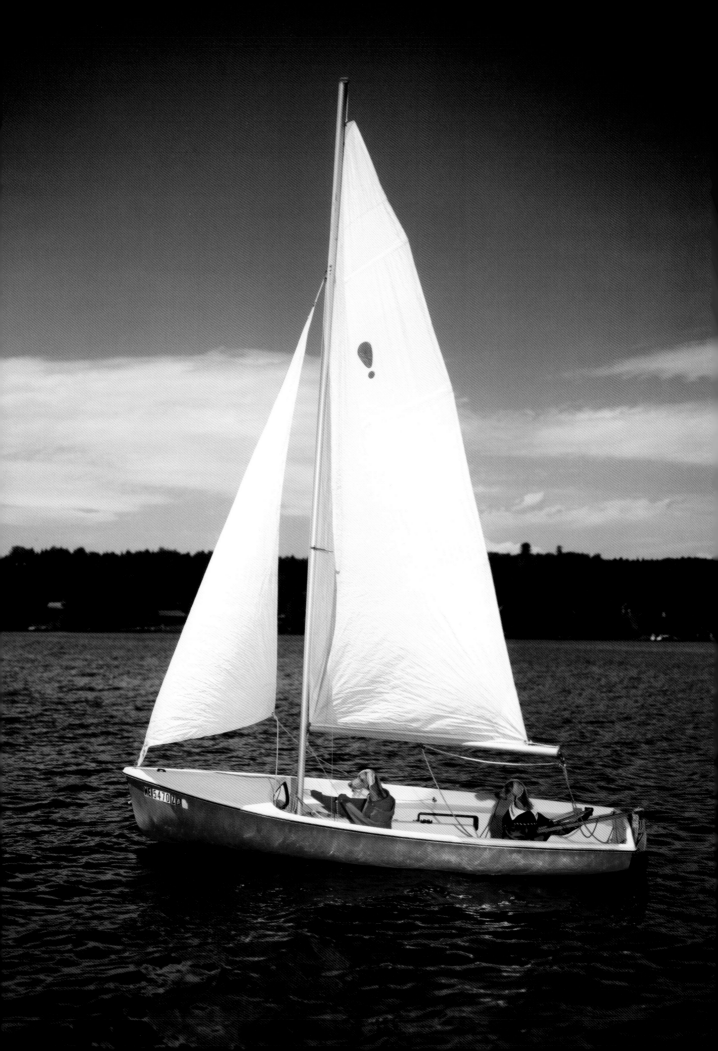

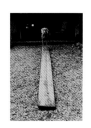

The Plank, 1994
Chromogenic print
14 x 11 inches

Shore Dinners, 1996
Altered card on paper
15 x 22¼ inches

Tents, 1996
Oil and acrylic on canvas
61 x 77 inches

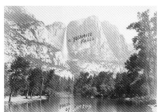

Photo By Watkins, 1997
Ink on found photograph
9 x 13 inches

Richard Long, 1997
Chromogenic print
11 x 14 inches

To Rangely with Thanks, 1998
Brochure and ink on paper
11 x 14 inches

Tangled, 1998
Found image, gouache, and ink on paper
12 x 9 inches

Untitled (Maine Timber Trails), 1998
Brochure, ink and gouache on paper
16 x 20 inches
Courtesy American Express
 Publishing Corporation

Untitled (Greetings from the Pine Tree State), 1998
Postcard on chromogenic print
20 x 16 inches
From the collection of Nancy Novogrod

Help, Kelp, 1998
Chromogenic print
14 x 11 inches

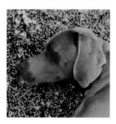

Non Pareil, 1998
Chromogenic print
14 x 11 inches

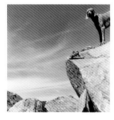

Split Rock, 1998
Chromogenic print
Two panels, 14 x 11 inches each

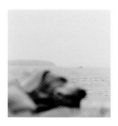

Summer Vacation, 1998
Chromogenic print
14 x 11 inches

Trap, 1998
Chromogenic print
14 x 11 inches

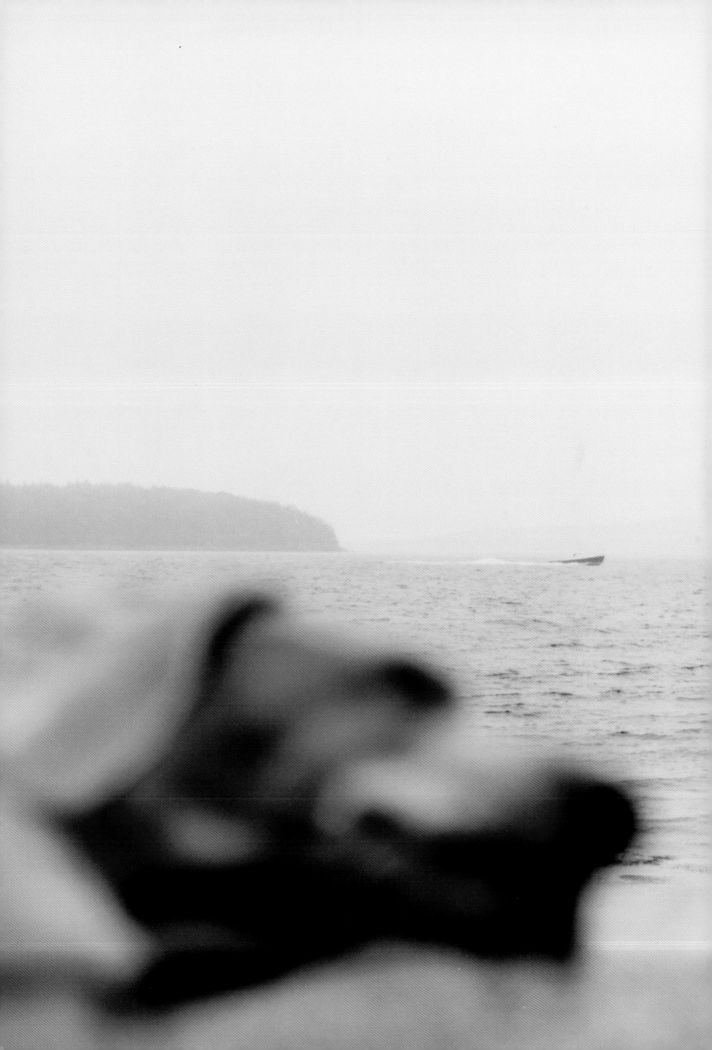

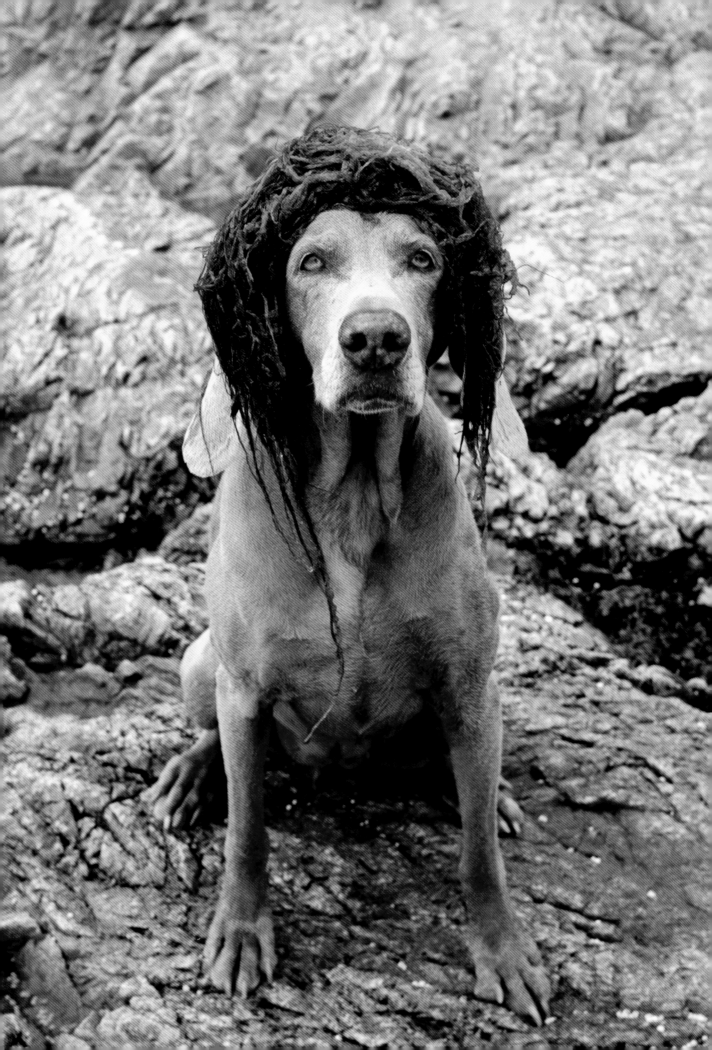

Water Work, 1998
Chromogenic print
14 x 11 inches

W, 1999
Chromogenic print
14 x 11 inches

Header, 2000
Chromogenic print
14 x 11 inches

Way Up In Maine, 2002
Found postcard and gouache on paper
22¼ x 30½ inches

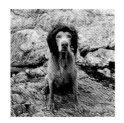

Algae Girl, 2002
Chromogenic print
14 x 11 inches

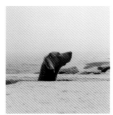

Fox Hole, 2002
Chromogenic print
14 x 11 inches

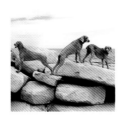

Ocean View, 2002
Chromogenic print
14 x 11 inches

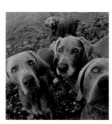

Seeing Eyes, 2002
Chromogenic print
14 x 11 inches

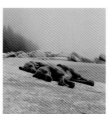

Washed Up, 2002
Chromogenic print
14 x 11 inches

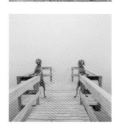

Arcade Game, 2003
Chromogenic print
14 x 11 inches

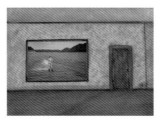

Lake View, 2006
Oil and postcard on wood panel
15 x 20 inches
Collection of Leisa & David Austin,
 Imago Galleries

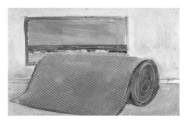

Ocean Carpet, 2006
Oil and postcard on wood panel
10⅜ x 16⅝ inches

Maine Postcards, 2006
Oil and postcards on wood panel
42 x 66 inches
Private Collection

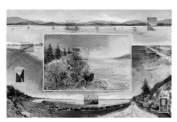

Mainer, 2006
Oil and postcards on wood panel
42 x 66 inches
Private Collection, Prouts Neck, ME

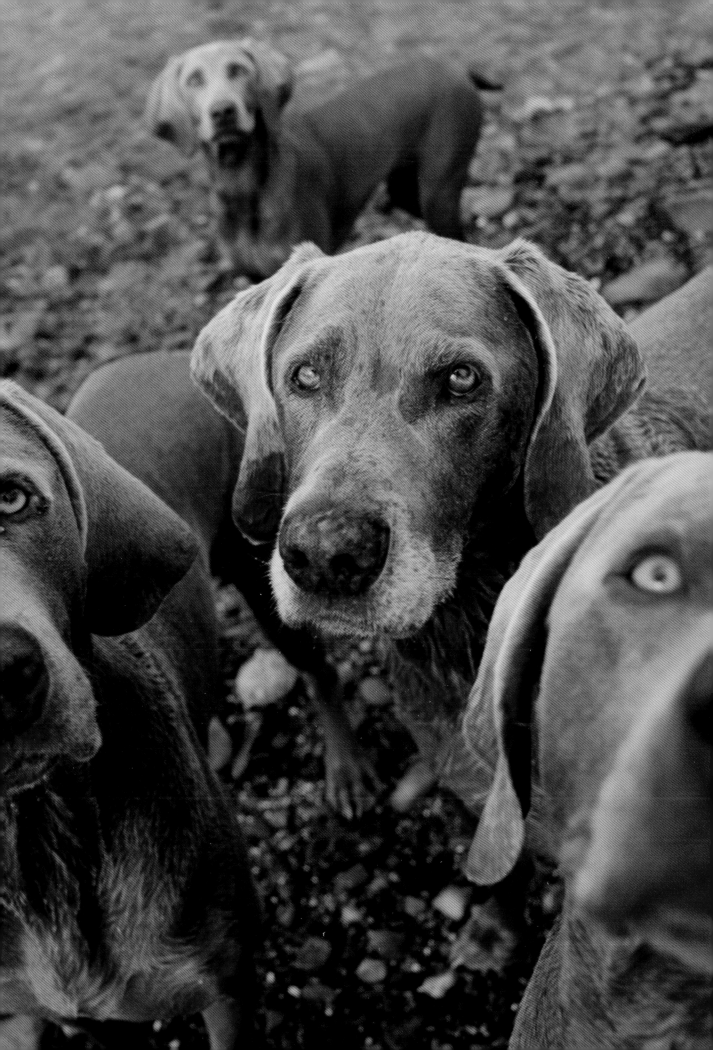

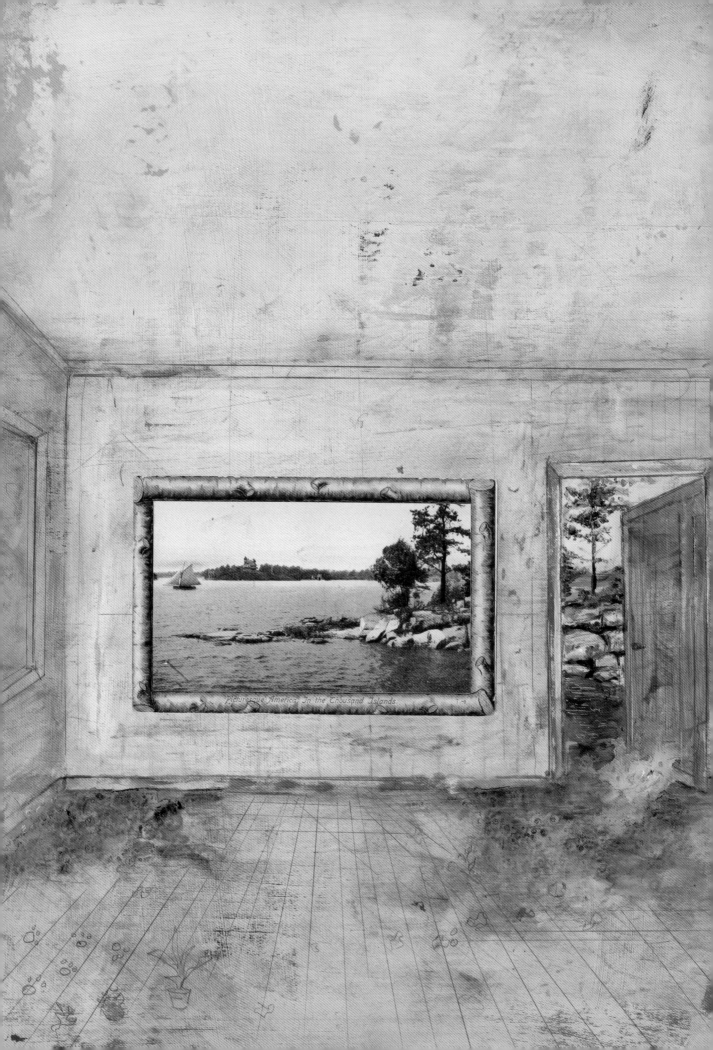

Picturesque America In the Thousand Islands.

The Beach/The Sky, 2006
Oil and postcards on wood panel
42 x 66 inches
Private Collection, Prouts Neck, ME

Road to Road, 2008
Oil and postcards on wood panel
12 x 15 inches

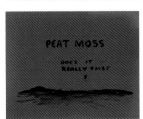

Peat Moss, 2010
Ink on photographic paper
11 x 14 inches

Room with a View, 2010
Oil and postcards on wood panel
16 x 12 inches
Collection of Fred Torres, New York

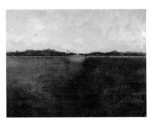

Vacancy, 2011
Oil and postcard on wood panel
30 x 40 inches

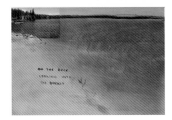

On the Dock Looking into Bucket, 2011
Oil and postcard on wood panel
12 x 17½ inches

Water Damage, 2012
Oil and postcard on wood panel
16 x 12 inches

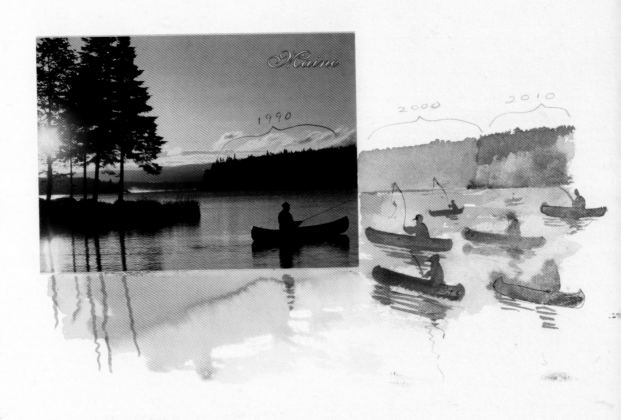

Acknowledgments

The artist would like to thank a lot of people for helping with this project. There were many. Especially artists Emily Helck and Jason Burch, who spent much of their time helping me with so much that has gone into this exhibition and book. Thanks to Mary DelMonico and Karen Farquhar at Prestel for going along with us, to Kevin Salatino of Bowdoin College Museum of Art for his thoughtful essay and for all the groundwork, to Diana Tuite for her thoughtful essay and brightness, to Padgett Powell for his startling memory and exceptional short story. Thanks to Laura Lindgren for her beautiful design and for letting us go back and forth, back and forth! Thanks to Ken Swezey for his wise counsel, and to my sister, Pam Wegman, for helping with so many projects that found their way into this book and exhibition. Thanks too to Marc Selwyn, for his illuminating insight, inspiration, and brilliant though unused title suggestion. Thanks to Stan Bartash posthumously, Maine forester and guide, who earned the right to wear buffalo plaid but chose not to; to Jerome Guevremont, known as the most intelligent person in Rangeley; and to David MacMillan, dentist, athlete, renaissance man. And most of all and as usual to Christine Burgin, whose love of books is almost as great as she is. Without her this whatever-it-is would not have been.
—William Wegman

William Wegman, Christine Burgin, and the Wegman studio have been nothing less than a joy to work with. They, along with Laura Lindgren, have made this catalogue, and the remarkable exhibition at the Bowdoin College Museum of Art that it accompanies, rich and wondrous things. I also want to second the thanks to Mary DelMonico and Karen Farquhar of DelMonico Books–Prestel; frankly, I don't know how they do what they do with such calm and aplomb. At Bowdoin College, particular thanks to Barry Mills, president, Cristle Collins Judd, dean for academic affairs, and Margaret Broaddus. At the Museum, kudos to the exhibition's co-curator Diana Tuite, as well as to the Museum's exemplary staff: Victoria Baldwin-Wilson, Suzanne Bergeron, Martina Duncan, Michelle Henning, Jo Hluska, Joachim Homann, Laura Latman, Liza Nelson, and Jose Ribas. Additional thanks are due to Angela Westwater and Sperone Westwater Gallery. The following lenders have been unstintingly generous with their works: Leisa and David Austin, Nancy Novogrod, Fred Torres, and Nina and Michael Zilkha. For exhibition support, a debt of gratitude for their generosity is owed the Amy P. Goldman Foundation through Donald Goldsmith, Frank M. Gren, Edward and Caroline Hyman, the Devonwood Foundation, Eric and Svetlana Silverman, Mary G. O'Connell and Peter J. Grua, Charles E. Hayward, and Senior & Shopmaker Gallery.
—Kevin Salatino, Director, Bowdoin College Museum of Art

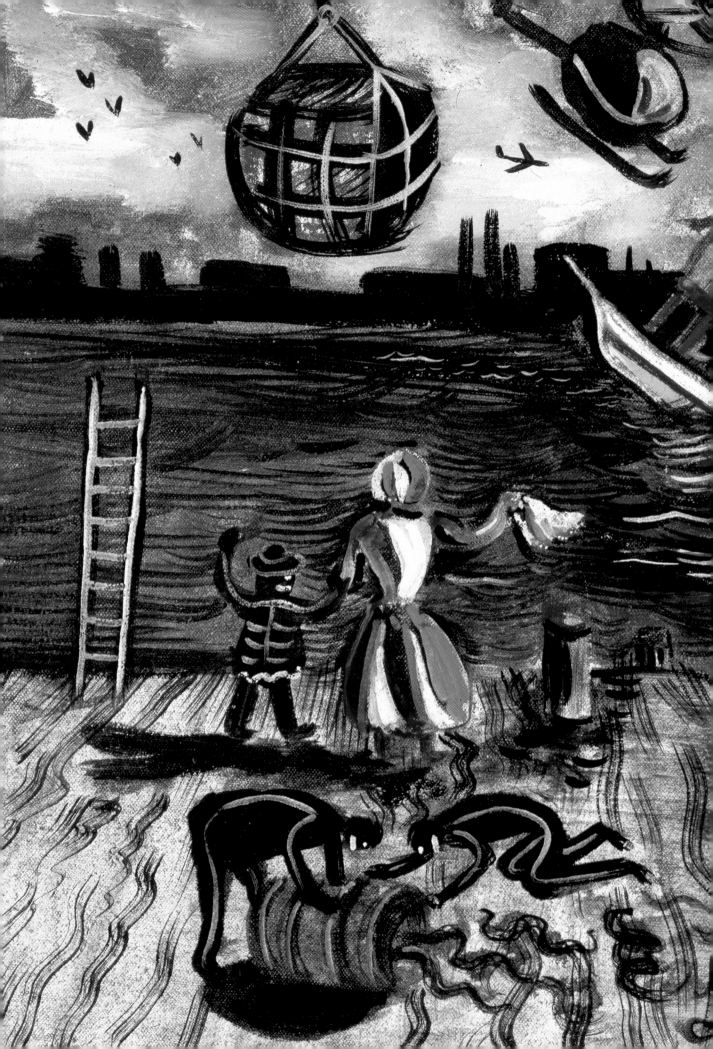

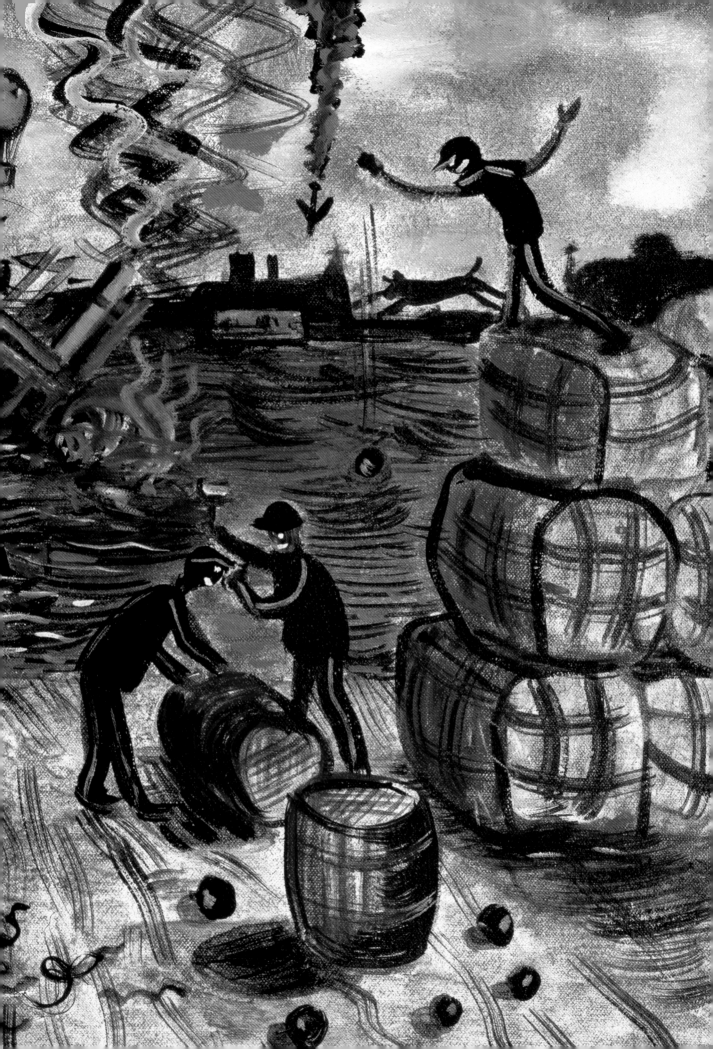

AGAIN AND AGAIN

You will always have

night and day,

sunrise

and sunset,

summer

and winter,

spring

and fall,

full moons and new moons,

high tides and low tides,

and waves that heave up and down.

These things never stop happening.
They will go on and on,
again and again,
and
again
and
again.

Published on the occasion of the exhibition *William Wegman: Hello Nature,* on view at the Bowdoin College Museum of Art, Brunswick, Maine, July 13–October 21, 2012.

Major support is provided by the Amy P. Goldman Foundation through Donald P. Goldsmith, Frank M. Gren, Edward and Caroline Hyman, the Devonwood Foundation, Eric and Svetlana Silverman, and the Elizabeth B. G. Hamlin Fund at Bowdoin College. Additional support provided by Mary G. O'Connell and Peter J. Grua, Charles E. Hayward, and Senior & Shopmaker Gallery.

Published by Bowdoin College Museum of Art and DelMonico Books, an imprint of Prestel

Bowdoin College Museum of Art
9400 College Station
Brunswick, Maine 04011
207-725-3275
www.bowdoin.edu/art-museum

Prestel, a member of Verlagsgruppe Random House GmbH

Prestel Verlag	Prestel Publishing Ltd.	Prestel Publishing
Neumarkter Strasse 28	4 Bloomsbury Place	900 Broadway, Suite 603
81673 Munich	London WC1A 2QA	New York, NY 10003
Germany	United Kingdom	tel 212 995 2720
tel 49 89 4136 0	tel 44 20 7323 5004	fax 212 995 2733
fax 49 89 4136 2335	fax 44 20 7636 8004	sales@prestel-usa.com
www.prestel.de		www.prestel.com

Designed by Laura Lindgren

Printed by C&C Offset Printing
Printed and bound in China

Library of Congress Cataloging-in-Publication Data
William Wegman : hello nature : how to draw, paint, cook, & find your way.
 pages cm
 Published on the occasion of the exhibition William Wegman: Hello Nature, on view at the Bowdoin College Museum of Art, Brunswick, Maine, July 13–October 21, 2012.
 Includes bibliographical references.
 ISBN 978-3-7913-5227-5 (hardcover)
 1. Wegman, William—Exhibitions. 2. Wegman, William—Sources. I. Wegman, William. Works. Selections. 2012. II. Bowdoin College. Museum of Art. III. Title: Hello nature.
 N6537.W345A4 2012
 700.92—dc23 2012010765

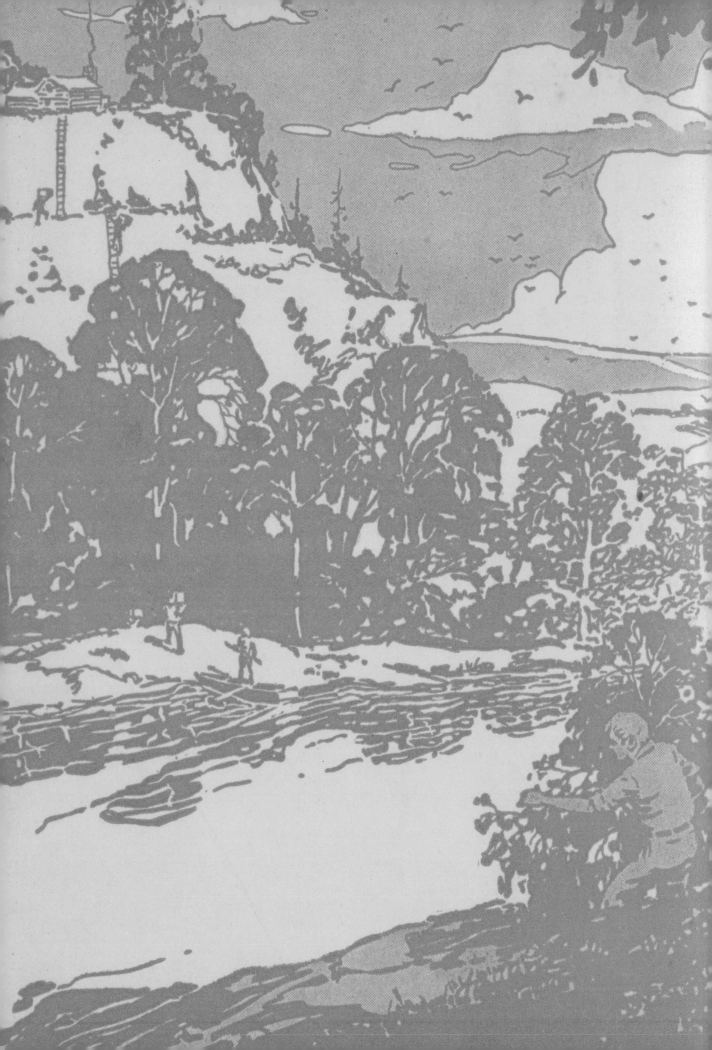